D1119992

ONCE AND FUTURE RIVER

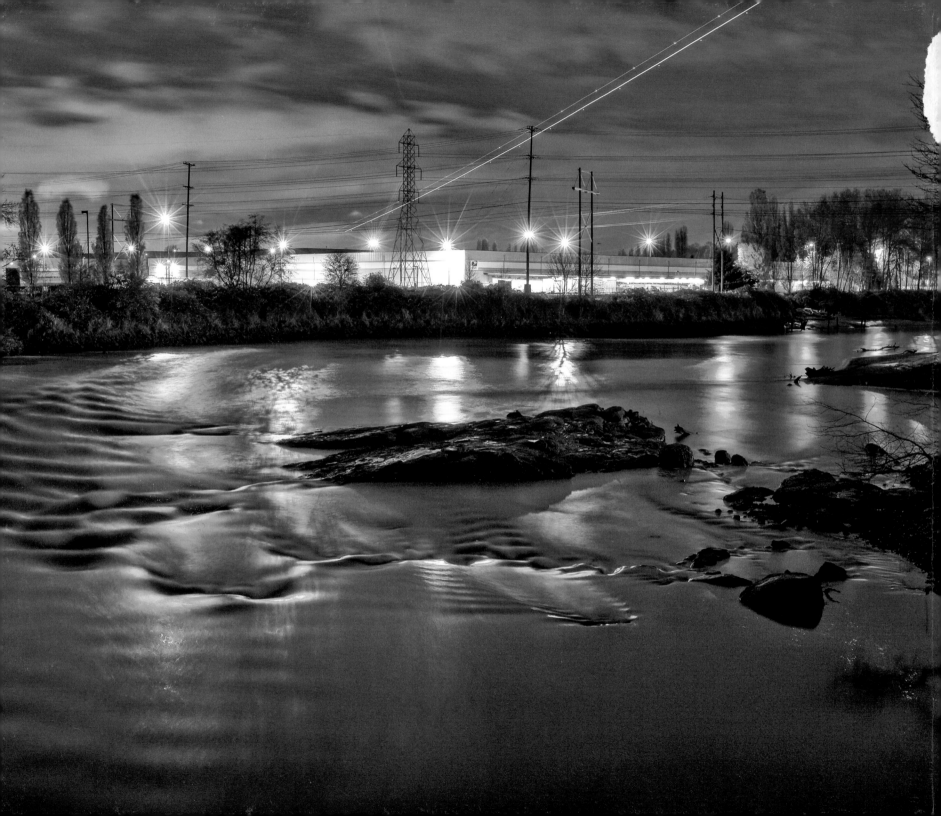

ONCE & FUTURE RIVER

RECLAIMING *the* DUWAMISH

PHOTOGRAPHS BY TOM REESE

ESSAY BY ERIC WAGNER

AFTERWORD BY JAMES RASMUSSEN
Duwamish Tribal member and director,
Duwamish River Cleanup Coalition

A Ruth Kirk Book

UNIVERSITY OF WASHINGTON PRESS
Seattle and London

Once and Future River was published with the assistance of a grant from the Ruth Kirk Book Fund, which supports publications that inform the general public on the history, natural history, archaeology, and Native cultures of the Pacific Northwest.

This book was supported by the Northwest Writers Fund, which promotes the work of some of the region's most talented nonfiction writers and was established through generous gifts from Linda and Peter Capell, Janet and John Creighton, Michael J. Repass, Robert Wack, and other donors.

The book also was made possible in part by a generous grant from the Pendleton and Elisabeth Carey Miller Charitable Foundation.

FRONTISPIECE: North Wind's Weir, where in Puget Sound Salish tradition Storm Wind defeated North Wind and reclaimed the world from under ice

UNIVERSITY OF WASHINGTON PRESS
www.washington.edu/uwpress

LIBRARY OF CONGRESS CATALOGING-IN-PUBLICATION DATA

Names: Reese, Tom (Thomas William), 1958– | Wagner, Eric J., writer of supplementary content. | Rasmussen, James (Duwamish tribal member), writer of supplementary content.

Title: Once and future river : reclaiming the Duwamish / photographs by Tom Reese ; essay by Eric Wagner ; afterword by James Rasmussen, Duwamish tribal member and director, Duwamish River Cleanup Coalition.

Description: Seattle : University of Washington Press, [2016]

Identifiers: LCCN 2015035770 | ISBN 9780295996653 (hardcover : alk. paper)

Subjects: LCSH: Water—Pollution—Washington (State)—Duwamish River Watershed—Pictorial works. | Duwamish River Watershed (Wash.)—Environmental conditions—Pictorial works. | Stream restoration—Washington (State)—Duwamish River Watershed. | Landscape photography—Washington (State)—Duwamish River Watershed.

Classification: LCC TD224.D86 R44 2016 | DDC 551.48/30979777—dc23

LC record available at http://lccn.loc.gov/2015035770

The paper used in this publication is acid-free and meets the minimum requirements of American National Standard for Information Sciences—Permanence of Paper for Printed Library Materials, ANSI Z39.48–1984. ∞

CONTENTS

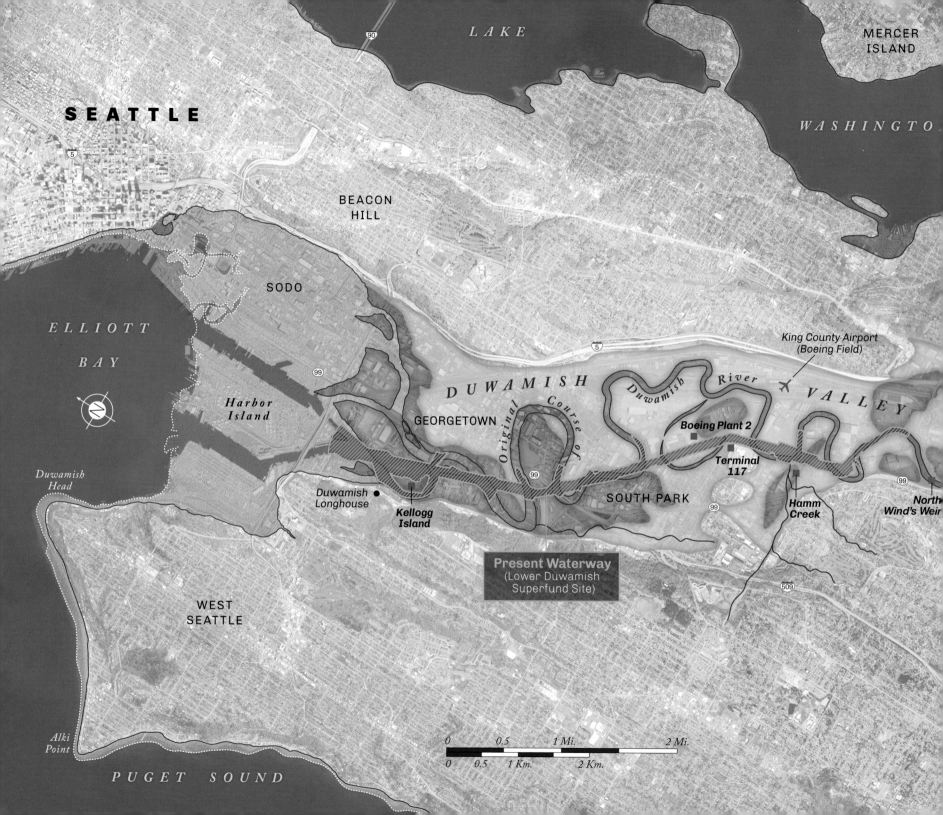

SEATTLE

LAKE

MERCER
ISLAND

WASHINGTO

BEACON
HILL

SODO

ELLIOTT
BAY

Harbor
Island

King County Airport
(Boeing Field)

DUWAMISH

Duwamish River

VALLEY

GEORGETOWN

Boeing Plant 2

Duwamish
Head

Duwamish
Longhouse

Kellogg
Island

Terminal
117

Original Course of

SOUTH PARK

Hamm
Creek

North
Wind's Weir

Present Waterway
(Lower Duwamish
Superfund Site)

WEST
SEATTLE

Alki
Point

PUGET SOUND

0 0.5 1 Mi. 2 Mi.

0 0.5 1 Km. 2 Km.

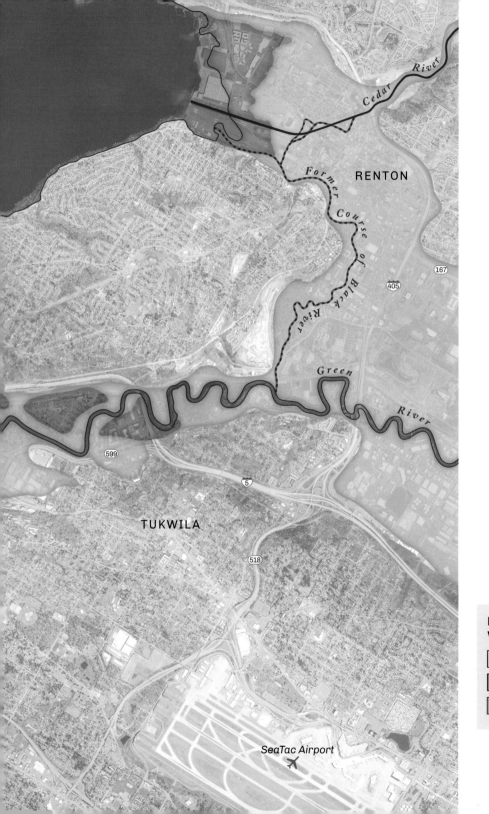

Cedar River

Former Course of Black River

RENTON

Green River

TUKWILA

SeaTac Airport

Duwamish River and Valley, Past and Present

- Duwamish Valley (Elevation 0–10 ft.)
- Former Wetlands
- Former River Channel and Tidal Mud Flats

ONCE AND FUTURE RIVER

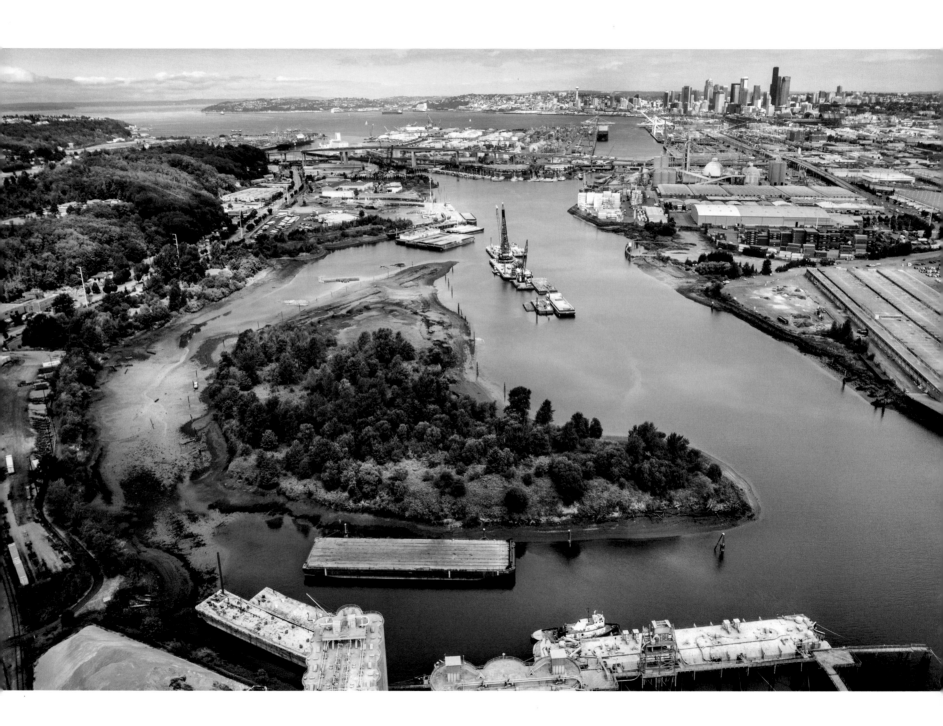

COLD LIKE THE RIVER

Eric Wagner

INTRODUCTION: TWO MAPS

Just past the entrance of the Duwamish Longhouse and Cultural Center, in a recess above a water fountain, is a large map. If not old itself the map has the aspect of age, its black script faded, its paper a weathered beige to match the wall on which it hangs. It shows a portion of western North America from the bottom of Vancouver Island and British Columbia south to Oregon, near Portland, and from the Pacific Ocean east to the lee of the Cascade Range. A few objects of geographic significance are marked: the larger islands, the odd cape or promontory, the mountains that look like blisters. Otherwise the map's most notable features are the many hairline cracks. These make the land look dry and brittle, but they are actually rivers, some great, some small, some named, most not.

The map is the work of a man named George Gibbs, who drew it in 1856. Gibbs was the scion of a prominent New York family. A portrait from his later years when he was an ethnologist with the Smithsonian Institution shows him

Last natural bend in lower
Duwamish at Kellogg Island

to be a classic nineteenth-century patrician, with clear steely eyes, fiercely pomaded dark hair, and a great mossy beard that he has allowed to consume the lower half of his face.

Staid though he may have ended up, as a younger man Gibbs was of a more romantic cast of mind. He had studied law at Harvard University, but in 1849 at the height of the gold rush he headed west. He settled first in the Oregon Territory, at Astoria, where he worked as a customs agent. Later he moved north to Fort Steilacoom on the shores of Puget Sound. For the next several years he devoted himself to the study of the Pacific Northwest's indigenous peoples. He was a skilled if amateur linguist, and compiled one of the first dictionaries of Chinook jargon, the regional trade language.

In 1853 Gibbs took a position with one of the great Pacific Railroad Surveys. Although he was officially a geologist he also recorded the distribution of the area's many tribes, as one might the ranges of birds. His 1856 map, one of the earliest of the Washington Territory, is a product of these efforts.

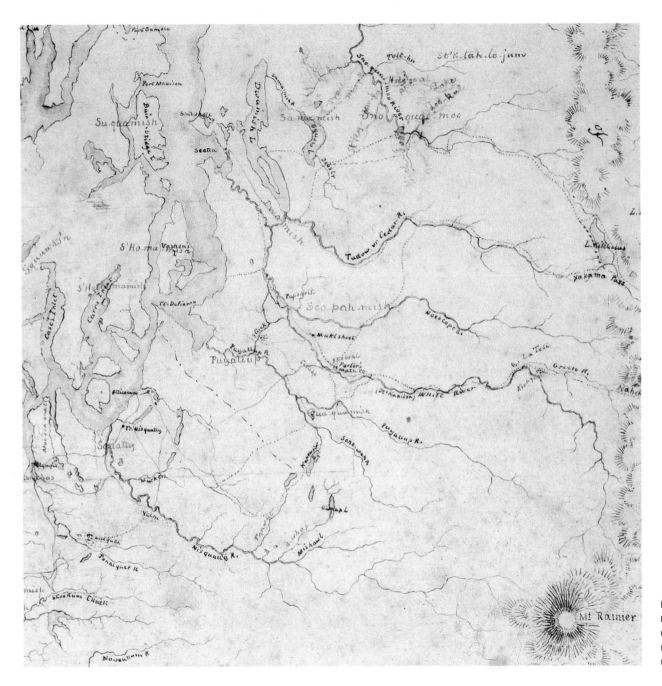

Detail from 1856 map of Puget Sound region by George Gibbs, showing tribes and their association with the landscape

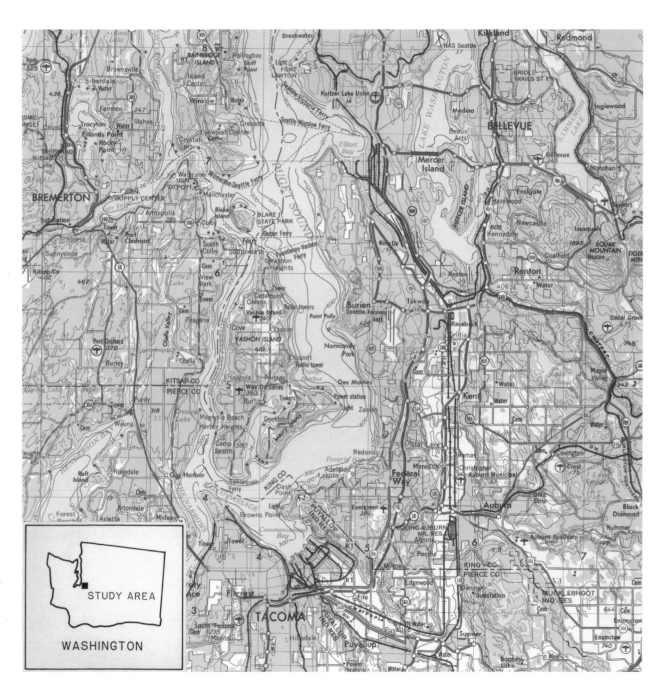

Map from 1958, the river unlabeled. From 1982 EPA publication *Aerial Photographic Analysis of Hazardous Waste Sites, Duwamish Valley, Washington*

In addition to setting down the features of the physical geography, Gibbs has written the names of the tribes in red ink, placing them roughly over their lands as he knew them.

So it is that penned in his careful hand near the center of the map is the name *Duwamish*. A little noodle of a river runs beside the word. In its modest place as part of a larger watershed this unnamed river emerges from a tangle of other, longer rivers that flow from the Cascades' high shadows down to Puget Sound. The small settlement that sat among the tidal flats at its mouth, Seattle, was less than ten years old.

The survey on which Gibbs worked was led by Isaac Stevens, the newly appointed governor of the Washington Territory. One of Stevens's early duties had been to make treaties between the United States and the Native Americans whose lands the federal government wished to possess. In this Gibbs proved invaluable. With his reputation as, in the words of one historian, the "most apt student of Indian languages and customs in the Northwest," he helped secure three major treaties with the Salish peoples around Puget Sound. One, the Treaty of Point Elliott, was signed in 1855 only a few miles from this cultural center. This treaty would ultimately compel many of the families that lived along the river to move to the Port Madison Indian Reservation on the Kitsap Peninsula.

Given Gibbs's central if quiet role in dispossessing the Duwamish people of their land, it seems odd that they would put his map here on a wall of their cultural center, but this is a place where history and its discontents regularly abut those of the present. Even as the river that the Duwamish people were forced to leave now bears their name, it is very much altered from the one Gibbs drew, so much so that I wonder whether that older river could be said to exist anymore.

. . .

All rivers change. Of the geographic bodies they are the most restless, the most inventive, always experimenting, always finding new paths for themselves. But some rivers change (or are changed) more than others, and to learn the current character of the Duwamish River, one has to consult a newer map. There are many, and each addresses its own occasions. Choose one: a map from 1958, by the U.S. Geological Survey (USGS). It is in a booklet titled, *Aerial Photographic Analysis of Hazardous Waste Sites, Duwamish Valley, Washington*, prepared for the Environmental Protection Agency (EPA) in 1982 by J.S. Duggan of the Lockheed Engineering and Management Services Company. On the third page, Duggan includes a section of the USGS's 1:250,000 topographic map of Seattle. It shows the area from the city south to Tacoma, and from Bremerton east to Squawk Mountain.

One hundred and two years passed between Gibbs's map and the one Duggan chose. This may not be long for a river, but it is more than enough time for people to busy themselves. The effects of their busyness on the Duwamish are awesome. Rather than rivers of water, the features that draw the eye on the USGS map are the roads and railroad tracks: rivers of cars, trucks, and trains. Where Gibbs was sparing in the information he included, the USGS is perhaps too generous. Finding the Duwamish River means searching through dense thickets of words and numbers, used to denote mountains, lakes, bays, cities, suburbs, towns, neighborhoods, county lines, state parks, Indian reservations, interstate freeways, state highways, roads, streets, drag strips, ferry routes, railroad tracks, airports (the runways, even!), power stations, light stations, substations, radio towers, water towers, naval bases, elevation gradients, and water depths. So thoroughly has the river been subsumed within the urban matrix that it is all but invisible, displaced from a document of which it is ostensibly the subject. But there it

is, again near the center of the map, almost ramrod straight from its mouth until it reaches Tukwila.

The landscape of the USGS map is stunning. People can speak of conquering nature, but to conquer something at least implies a respect for it: the thing to conquer has an unsettling power that has to be suppressed. The Duwamish River cannot claim such dignity. As is only too clear, the once-small settlement of Seattle has grown and grown and swallowed up its only river. The river's last five miles are no longer even a river, having been rechristened the Lower Duwamish Waterway more than a century ago. Nineteen years after Duggan included this map, the EPA would further modify the name of that short stretch of water to the Lower Duwamish Waterway Superfund Site.

Calling something a Superfund site pronounces a special kind of environmental doom upon it, but if in that designation Seattleites have reached an end of their forsaken river they are also in a way at its beginning. In the years since the Duwamish became one of the most polluted water bodies in the United States, the people who live along the waterway have resolved to clean it, to restore it, to turn it back into a river.

To restore a place, writes William Jordan, the biologist who helped found the field of restoration ecology, is to try to make nature whole again. Restoration seeks to heal scars or erase signs of disturbance. In this it is an acknowledgment of deep culpability. We restore in part because we are to blame and we know it. We feel remorse, sadness, or anger for what was done, even if we were not directly party to it. We hope to make amends, to undo, even to reverse if we can. In seeking such a reversal restoration becomes a question of time, and therefore a historical exercise as much as it is a moral or spiritual one. What point in the river's past should we aim for? When was it the best version of itself? What processes from that period can we bring back now?

Restoring the Duwamish will mean reconciling the map from 1856 with the one from 1958, and other maps besides, finding ways that not only recognize the river's former course and inhabitants (some human, most not), but also account for the environmental and social cares of its more dismal present circumstances. The work will not be easy. To dwell on a river as dirty as this one can be difficult, especially in a city whose citizens take so much pride in their progressive environmental sensibilities. But to look hard at the Duwamish, to travel its length and stop now and again to consider what is there and what it might mean, speaks to the value of seeing this river from the other side of desecration. I think of a verse from the last of T. S. Eliot's *Four Quartets*, "Little Gidding." It might be the credo for all such restorations:

> What we call the beginning is often the end.
> And to make an end is to make a beginning.
> The end is where we start from.

This end that is also a beginning is where we now meet the Lower Duwamish Waterway, and beyond that the Duwamish River. We strive for a past we have never known, having only read about it, or seen it in faded pictures, or heard of it in stories about an old, shadowed river that once ran so full of life and magic that it filled the people who lived on it with awe, terror, and love. When we arrive at that place—if we are capable of reaching it, if we can recognize it should we get there—we will have found a way of seeing something that has until now been ignored, dismissed, and very nearly lost: a river from end to beginning.

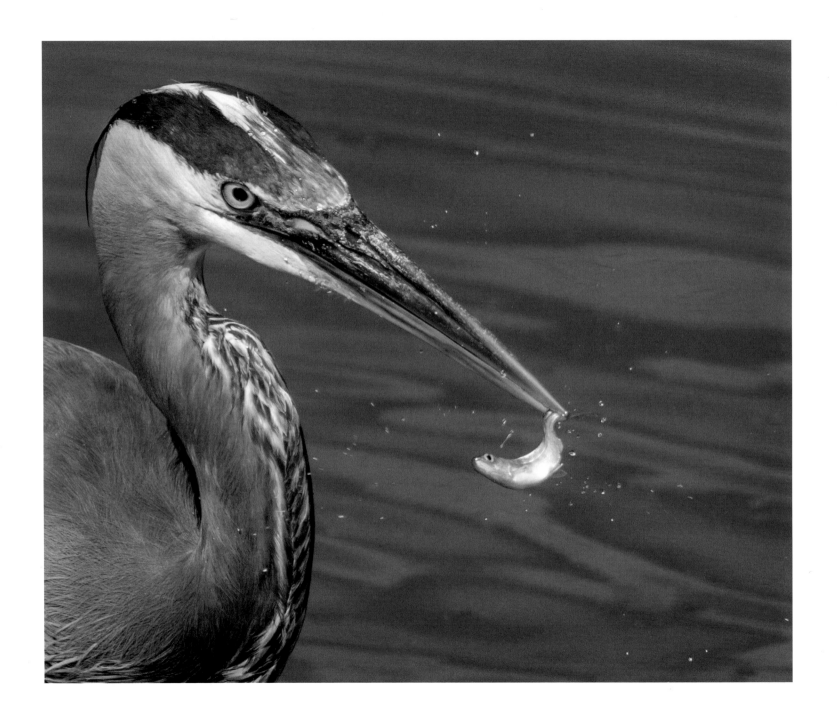

I NORTH WIND'S WEIR

North Wind overcame Chinook Wind and his people and estab-
lished himself on the Duwamish River. There, he built an ice dam
to keep the salmon from swimming upstream. He covered the
earth with winter, with ice and snow, and desolation.

At high tide a few miles from its mouth, the Duwamish River
sits sluggish like oil. With the Green River pushing it out from
behind and Elliott Bay backing it up from before, it does not
seem slack so much as doubly pressed. Perhaps it no longer has
the energy to contend with those larger forces set against it.

There is a small marsh here, a little more than two acres
in size. For the river the marsh seems to offer a chance to
leave the cares of its main stem, which would have it run in
and run out and do little else. In this meek space it can linger.
Small eddies form as it swirls its way around.

The banks of the marsh are a mess
of cottonwood, dogwood, fir, maple,
pine, spruce, willow. Smaller shrubs and

Great blue heron and juvenile fish in
restored habitat at North Wind's Weir

grasses cover the ground: hazelnut, ocean spray, sedge, wild
rose. Everything is young, nothing more than a few feet tall.
The thicket is so dense as to be impenetrable, save for one or
two paths that sneak down to the water's edge. A small islet
is a few feet from shore. I could probably walk to it without
much trouble, but when the tide is high, as it is now, the
submerged isthmus is muddy and uninviting.

I look out instead over the brackish waters. Dead trees lie
prone, stripped of bark, slick with algae. Most are in groups
of four or five, their boles stacked one on top of another,
their rootballs exposed. The arrangement suggests a larger
scheme. Just what this scheme might be becomes clearer
right before noon, when the tide turns. As the water inches
down, the heavy chains that hold the trees in place emerge,
revealing the marsh's truer character. It is a diorama of accel-
erated ecology: the trees and shrubs and grasses that would
otherwise grow to their own successional cadences have in-
stead been put in the ground all at once, and the logs that

might shift with the rhythms of the waters are nailed into the mud with rebar. But while I wonder whether the Duwamish River of today has the strength to move even one dead tree unaided, I understand the urge to hurry things along. Who anymore has the time or patience to wait for nature to work on its own?

The marsh continues to empty.

Chinook Wind's wife, Mountain Beaver Woman, had escaped. She went up the river and hid and gave birth to a son. He was Storm Wind. When he was young his grandfather said, "Never go over yonder!" But as the young man grew he liked to explore and hunt. One day he went down to the river. There he heard his grandmother crying and went over to her house, which was on a nearby hill. Her name was sqwalA'ts *and she was mourning her dead son, Chinook Wind. But as Storm Wind approached she became so warm that she began to sweat. Then she knew he was one of her people. "Is that you, my grandson?" she asked. And he answered, "Yes."*

When King County bought this land in 2001, it was a junkyard across the road from the Boeing Company's Commercial Aviation Services complex in Tukwila. Pallets and old cars and trucks were strewn about, but the refuse hid special qualities. Not only was this one of the last undeveloped shorelines along the Duwamish River, it was also the farthest that saltwater from Puget Sound could reach to mix with the river's freshwater. Intact estuary like this is rare on the Duwamish; less than 5 percent of its historical complement remains. If this small space could be restored to something that approximated its original state, biologists reasoned, then it might help revive the threatened Duwamish/Green River run of Chinook salmon.

The Chinook, or king, is the largest species of Pacific salmon and also the most sought after, prized both for its fight and for the richness of its meat. The grandest specimens may reach five feet in length and weigh more than a hundred pounds, but life for Chinook salmon begins modestly, in a small creek or stream. There they hatch from eggs laid in a gravel bowl, called a redd, that their dying mother has scoured from the creek bed. As fry they might stay in their natal river for up to a year before starting for the sea, where they will spend most of their lives. Their last stop will be in an estuary like this one.

To young salmon the estuary is a place of becoming. Here their bodies acclimate to the sea's demands. How long they stay varies both by the species and by the run, but Chinook salmon generally use the estuary the longest. Even so, the habits of wild Duwamish/Green River Chinook are still largely unknown. Some might come here as fry, having hatched a few weeks before. When they nose into the marsh for the first time they are the size of a pine needle, and must learn to feed on their own over the coming months. In the calm water they hunt for insects among the woody debris, darting in and out of the shadows.

Others arrive in the estuary near the end of their first year, as smolts. In their haste to reach the ocean they might stop for only a few days, or for a week or so. Almost twice the size of fry—which is to say, all of five inches long—smolts are better prepared for the exigencies of saltwater. They have a sleeker, fishier form, and their scales flash silver and blue so that they might better blend with the brighter waters of the sea, which they yearn to taste.

Storm Wind went down to the riverbank where North Wind had his fish weir made of ice. Uprooting a cottonwood, he cast it in the river. It floated down and lodged itself on the weir. North Wind called all his people to help remove it. They tried but could

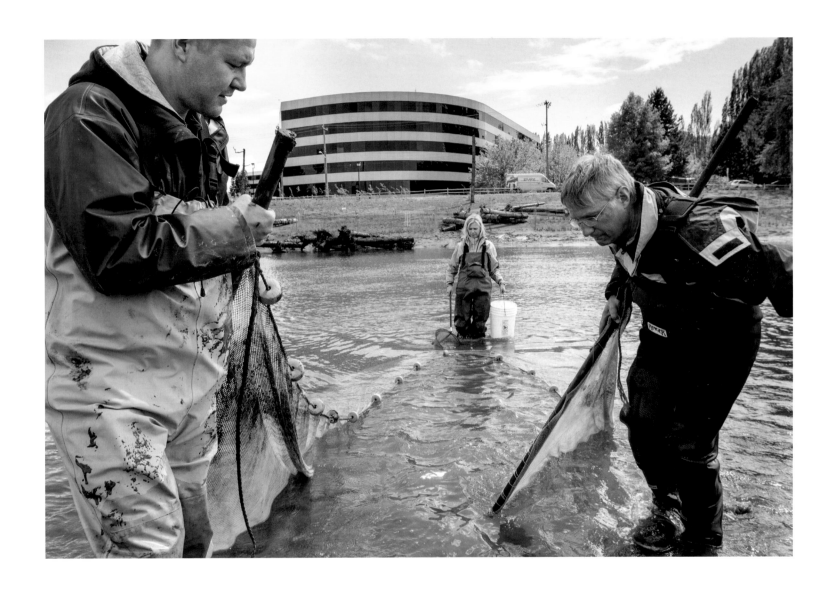

Researchers study effectiveness of
habitat restoration by counting juve-
nile fish and invertebrates

not. They saw a man reclining on the farther bank. "It must be the grown son of Chinook Wind, whom we destroyed," they murmured. Then North Wind himself called to the man: "Stranger! Chieftain! I would thank you for your help in removing the drift from my weir." The young man lifted the log with his foot as though it were a bundle of feathers. He tossed it over the trap and it floated away. Seeing the youth's strength, North Wind was so alarmed that he offered his daughter in marriage.

Nearly ten years passed before the marsh site would be ready for its imagined occupants, the young salmon. As can happen in restoration ecology the question was one of money, or its lack, but once the county secured the more than five million dollars that was needed, the difficult work of reacquainting the land with the river began. In 2008, all the pallets and cars and trucks were removed. Buried chunks of concrete, some as big as refrigerators, were dug up and hauled away. Engineers then spent the first months of 2009 excavating several hundred tons of oil-laced soils. That work done, bulldozers and earthmovers started to dig out a small side channel to mimic what an unhindered river might have carved on its own. The following December the Duwamish was allowed to overtop a berm, filling the space for the first time. The water stayed for a few hours before the departing tide drew it away, but it was back the next day, and the day after, and with that cycle renewed the site joined the river.

An empty canvas of bare earth remained above the waterline. Plans were made for its transformation, parsing it down to the last square inch. Downstream slopes would have 20 percent red osier dogwood and 70 percent live willow, the latter placed at one stem per foot. Snags were to have a substantial portion of their limbs intact; broken or damaged tops were preferred. There would be, planted in the appropriate

zones, eight shore pine, eleven Oregon ash, four hundred Sitka willow, eight thousand plugs of Lyngby's sedge. These plans went on for pages, giddy with the confident expectation that comes from near total control. At the groundbreaking for the main construction phase, representatives from various agencies sank their spades into the dirt to uncover a wooden crate full of little chocolate salmon, a promise of the fish sure to come.

Slowly the landscape lost its sad, gray cast, trading it for the healthful ruddiness of beauty bark, the fresher green of newly installed aquatic vegetation. Hundreds of volunteers came to spend hundreds of hours planting seedlings and shrubs. The project was completed in 2010, and Chinook salmon started to use the marsh soon after. If I look carefully now—or, rather, if I don't look at all—I can see them: a gathering of shiny little fish, drifting at the periphery of vision. They hover in the brown water almost motionless, the sun flickering off their bodies. I try to mirror their stillness lest I scare them away, but it is impossible to match a fish's repose, at once so languid-seeming but alert. My foot shifts, my image on the water wavers, and the smolts vanish. It is like they were never there.

To know all the labor that went into this marsh is to marvel at the feat, and the presence of the young salmon is more moving still. But the scene is somehow unsettling. Maybe it is because the marsh is so small. Even on a river only twelve miles long it shows how much is left to do, how much it will cost, how it will have to be tended far into the future, how the work will never be complete. There are deeper misgivings also. Everything we do to the land is a story, and a landscape holds every story ever told about it, each layered atop its predecessors. The marsh is just the most recent tale told here. In this version the Duwamish is broken and stunted, and so it was fixed, or this part of

it anyway, for the good of everyone as well as the river. "A town needs the river to forgive the town," wrote the poet Richard Hugo, who grew up near here. Every tree and bush and plug of grass is an expression of that need. Perhaps that is why there are so many of them. Every salmon in turn is a sign of absolution from the river. Perhaps that is why there are so few.

Storm Wind returned home to his grandmother. He found her weaving baskets to hold rain. Now that her grandson was strong she was preparing to fight North Wind. Her first baskets were large and coarsely woven to hold big raindrops. The next in size and weave were for steady rain. The smallest were tightly woven and were to hold fine mist. Storm Wind blew upon the earth and brought his parents back to life. He blew again and his vanquished people were unfrozen, too. "What day shall we fight?" he asked his grandmother. "Tomorrow is the day upon which we may fight," she said.

The tide keeps falling. The river has a restless churn now, picking up speed as it sweeps past. Just beyond the marsh slabs of flat stone start to appear. They finger out into the river, reaching within twenty feet of the opposite bank. I see that once fully exposed they will force the Duwamish through a narrow chute.

The marsh and trees and needle salmon might be new and still learning their way, but these rocks look old. Older than old: bedrock, from when the land was still young. They are what give this place its name: North Wind's Weir.

Six concrete panels next to the Boeing parking lot depict the story of the great battle fought here in an ageless past. The story is from a set of Salish legends called the Epic of the Winds. It tells of how cold, treacherous North Wind and warm, wet Storm Wind clashed for control of the weir. His-

torian Coll Thrush has hypothesized that the story was born out of the preserved memories of the last ice age, when the glaciers retreated thousands of years ago. Every year since then the winds have refought their battle in the wild storms of fall and winter.

I watch the weir grow out of the water as if it is being roused from slumber. The ur-geography of Puget Sound abounds with sites like this, mostly anonymous but still thrumming with the resonances of older landscapes. Whoever ruled the weir ruled the river. Nothing less than the character of the region was at stake—its soul, the fate of its people. This continues to be true.

I picture a youth who is Storm Wind lounging on the far shore, which today is covered with old tires. I watch him kick over trees as if they are bundles of feathers. He leans back with indolent strength and crosses his legs, puts his hands behind his head, surveys all before him. What would he make of the chains and rebar tasked with holding the dead trees against his whims, his vicissitudes? He would probably laugh.

So on the morrow they began the contest. Storm Wind blew a warm wind. His grandmother began pouring out the rains all over the frozen valley: first the coarse drops, then the steady rain, and lastly the mist. Storm Wind blew and the rains washed through the valley in a great flood. He blew again and uprooted the trees. The floods carried the trees and smashed them into the weir, breaking through the ice, so that the salmon could swim upriver again. Together Storm Wind and his grandmother beat back North Wind and chased him away. They melted the ice and blew it after him. Only the weir was left.

North Wind's Weir. The name itself is poetry, the wind recapitulated in the utterance. "For the most part," Nietzsche

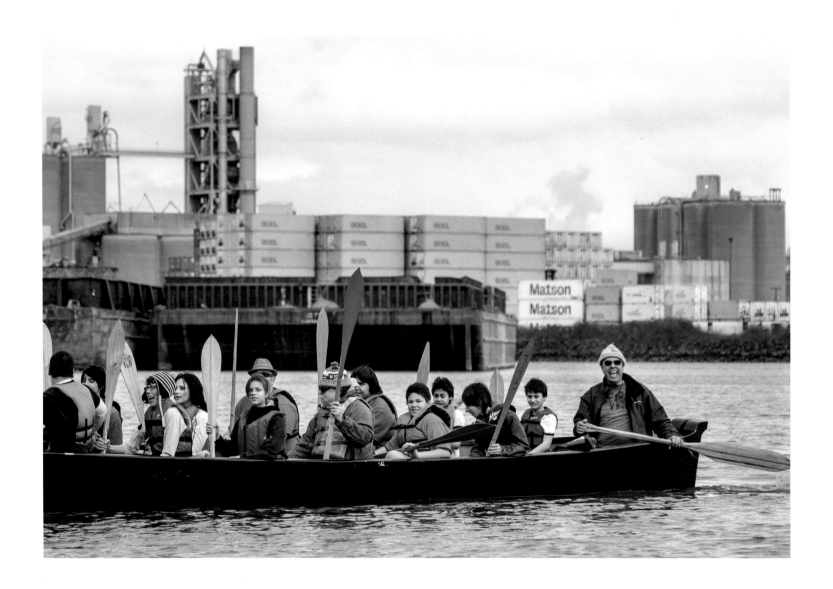

Blue Heron Canoe team and guests come ashore near Duwamish Longhouse and Cultural Center

wrote, "the original ones have also been the name-givers," and it would be nice to think that North Wind's Weir is the original name of this place. But that is not true. Rather, the English version is an elaboration of *quláXad*, which simply means "barrier" in Lushootseed, the language of the Salish peoples who were the area's first human inhabitants.

The story of the battle between North Wind and Storm Wind as it is widely known is adapted from *Mythology of Southern Puget Sound*, by Arthur Ballard. This particular version, one of seven (and one that I have also modified to suit my own needs), was related to Ballard by Charles So-taiakum, who had lived on the Duwamish River. Other versions come from people who had lived on the Green River or Lake Washington. Ballard credits them all: Big John on the Muckleshoot Reservation, Joe Young, Dan Silelus, Sampson and Lucy. The subtle differences among the versions reflect the diversity of the tellers, the changes the story underwent as it made its way around the clans in the region. In Ann Jack's version Mountain Beaver Woman has two slaves, Short-Tailed Rat and Mole, who steal food for her. Major Hamilton tells that as Chinook Wind's son grows older he starts to become Chinook Wind, rather than being just Storm Wind.

Ballard was an amateur anthropologist who started visiting reservations around Puget Sound as a teenager to gather legends and place names. He published his findings in 1929. By then the Salish peoples on this part of Puget Sound—the Duwamish (People of the Inside), the Suquamish (People on the Clear Salt Water), the Snoqualmie (People of Moon the Transformer), and others—had been enfolded into the story of Seattle for almost eighty years.

Their history is unique; its trajectory is not. As a people the Duwamish have lived on the river for more than ten thousand years. They and their culture are bound to it—to its bounty, to its storied geography—and the river to them. Their ancestors guided Colonel Isaac Ebey when he first explored the area in the spring of 1850. He canoed past their villages on the riverbanks, past the many long-houses and potlatch buildings. But he did not see so well the people who already lived here, looking at the land as he was through a different lens. "The river meanders along through rich bottom land, not heavily timbered," he would write to entice would-be settlers from the south, "with here and there a beautiful plain of unrivaled fertility, peeping out through a fringe of vine maple, alder or ash, or boldly presenting a full view of their native richness and undying verdure."

The next year the Duwamish greeted the area's first white settlers, the Collins Party, when they arrived to claim the land for themselves in the valley at what is now Georgetown; later the Duwamish welcomed the Denny Party to what they called *sbaqWábaqs*, or Prairie Point, now known as Alki Point. In 1852, the settlers decided to name their new home Seattle after Si'ahl, the leader of the local Duwamish band. The years passed and more settlers came, spreading their own designs and aspirations along the shores of Elliott Bay. As the small settlement grew the Duwamish found work as laborers in Henry Yesler's saw-mill. They packed salmon for Doc Maynard. They cleared the land and helped build homes, and some worked as domestic servants in those homes. They worked in brothels. Their contributions were vital to Seattle in those early days, when one early settler would describe the place as "a very small village, really more Indian than White!" Those conditions would change. Tensions rose as white settlers began to look at the Duwamish and Native people throughout Puget Sound with greater hostility, if not out-right scorn. Indians were savages, the antithesis of prog-

ress, a drag on the pioneer spirit. How had they managed to live here for so long without exploiting everything the land had to offer?

Once Si'ahl signed his *X* on the Treaty of Point Elliott in 1855, many of the Duwamish lost their homes and had to move to reservations around Puget Sound. (The treaty preserved their hunting and fishing rights and paid them $150,000, but unlike other peoples, the Duwamish never received a reservation of their own.) A few homesteaded, but Native Americans were forbidden from owning land within the city limits. Some fought and were forcibly subdued. Others chose to stay in the city, in shantytowns and tenement houses. Those who lived on the reservations did so under the watch of agents from the Bureau of Indian Affairs. Their children were sent to boarding schools where they were forbidden to speak their native languages or to act according to their customs. Smallpox and measles ravaged entire families. Arsonists set fire to the old longhouses and potlatch houses to burn away the Native presence. With the people of the river erased it would be easier to attend to the river itself, to shape it.

Today the Duwamish do not exist as a tribe, at least not officially, having been denied federal recognition. The current members of the Duwamish, who number about six hundred, have petitioned the government for nearly forty years to be recognized. Save for a brief moment in 2001 when it appeared they had at last gained official status, only to watch it be snatched away, their entreaties have been rejected. Most recently, in 2015, the director of the Office of Federal Acknowledgment in the Department of the Interior informed the Duwamish that they were "not entitled to be acknowledged as an Indian tribe." The Duwamish have vowed to appeal. It is unclear if they will ever succeed.

This story has none of the romance of the Epic of the Winds. That is most likely why there is little evidence of the marsh's actual place in history here. Myth and legend, gauzy and at a more distant temporal remove, will always be preferred. When biologists speak of the site they use the more technical language of ecological function: tidal influx, soil retention, dissolved organic matter. That they do so makes sense. Some things are more easily brought back to life than others. Restoring the full measure of everything that was lost on the Duwamish in any case is not what they were brought here to do. Still, it is good to be reminded how many fates are joined to the river, and that it was, and is, worth fighting over, worth fighting for.

The remains of North Wind's weir became stone, and can be seen today. If the young man had not been born, we should still have the ice here.

The river drops still more. It seems to have been falling forever, but the tide is nearing its nadir. Soon the marsh will flood and all of this—the dead trees, the chains and rebar that hold them, the mudflat dug for them, the weir, the simmer of its story—will disappear, hidden under water so flat and calm that it gives no sign of there being anything beneath its surface. But that time is yet to come. Now, in the dying light of late afternoon, the voice of the Duwamish rises to a roar as the river plunges through the chute of the weir. The water is white and moves so fast that standing waves form, flinging spray as if in fury. Who knew this river could still wield such energy, such power? Maybe the waters know that this might be their only chance to leave and so they have to hurry if they are to reach the bay before the tide turns again, forcing them back in. Or maybe the waves fly not so much with haste as with joy, as the river

sloughs off its heaviness for a time and lays bare its motive force, bucking, leaping, and dancing to an old and dimly remembered song.

II KELLOGG ISLAND

The best engineering is that which adapts itself to situations so that its works seem to have an inherent right to be where they are.

—HIRAM M. CHITTENDEN,
U.S. Army Corps of Engineers

On the afternoon of December 29, 1906, a few hundred people gathered in a large meeting room in Mystic Hall, in the town of Auburn, Washington. The group was a varied one, made up of state senators, mayors, landowners from Pierce and King Counties, delegates from the Seattle and Tacoma Chambers of Commerce, representatives from area railroads. They had come to discuss the state of the region's rivers and the dangers those rivers would pose if they were allowed to run as they wished.

In central Puget Sound it was impossible to find land more than a few miles from a river. The Green River, the White, the Stuck, the Puyallup, the Cedar, the Black, the Duwamish—theirs was a complex geography, meandering and interconnected, like the sutures on a skull. Starting from the central Cascades, the Green River flowed northwest, while the White approached from Mount Rainier to the south. A few miles northeast of Auburn the White merged with the Green and ran toward Elliott Bay. Just south of that juncture the Stuck, more a large creek than a river, branched from the White to join the Puyallup. The Puyallup, which like the White traced its headwaters to the glaciers of Mount Rainier, ran to Commencement Bay in Tacoma. North and roughly parallel to the White was the Cedar. Like the Green it began in the central Cascades, but it angled toward Lake Washington, until just below the town of Renton the Black cut the Cedar off from its putative destination, diverting instead to the White. Where White and Black met both rivers ended and the Duwamish began, flowing the final twenty miles or so to Elliott Bay.

Madrone tree sprouts from nurse log on Kellogg Island

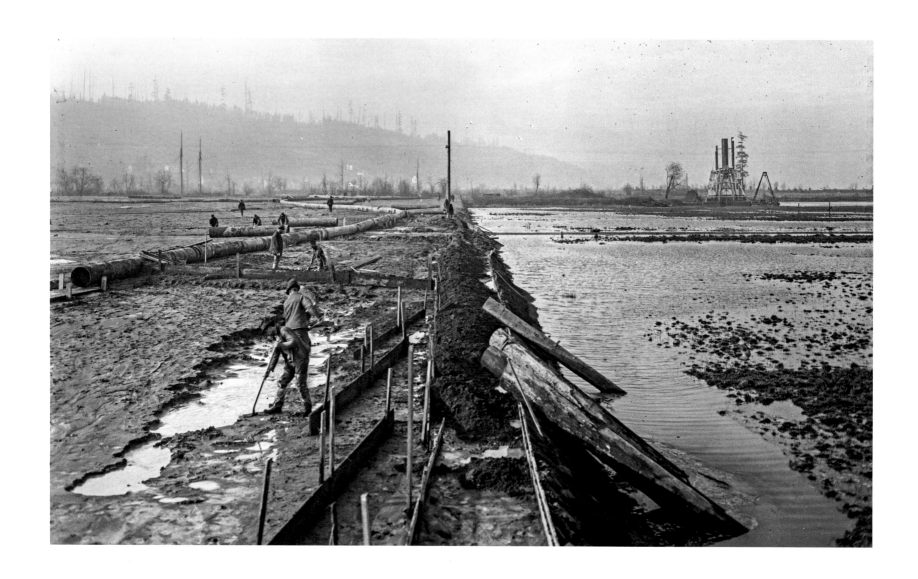

Workers lay pipe in new fill along
Duwamish Waterway, 1914

At issue that December day were the whims of the White. The White River tended to flood every few years, sometimes spectacularly, and people in King County wanted to shunt those floods to Pierce County. Pierce County residents, as might be expected, were resistant to the idea. Lawsuits had been filed to try to compel the White one way or the other and there had been the occasional guerilla action (clandestine shoveling, dynamite-induced landslides), but after more than twenty years the two counties had settled into a stalemate, with the river between them.

Then, in September 1906, the Chinook winds had come. They were a month early and strong. Their rain swelled the rivers. Unusually warm weather followed that November, melting snow in the Cascades. The meltwater inundated already-saturated ground, and the excess ran to the lowlands. On November 14, two inches of rain fell in the valleys with more still in the mountains, adding to the torrents. The rivers crested and overran their banks. They swept away houses, roads, highway and railroad bridges. Thousands of acres of farmland were buried under silt. People in the town of Kent awoke the next day to find themselves isolated on an island, surrounded by the floods.

Newspapers all over the country ran photos of the devastation, but as the floodwaters receded it became clear that the greatest consequences were geomorphological rather than infrastructural or economic. Just south of Auburn the White River had pushed tons of driftwood against a railroad bridge until a huge logjam formed. Backed up, in search of relief, the White had cut its banks and flowed across the few hundred feet of land that separated it from the Stuck River. It swamped the smaller Stuck and appropriated its channel, flowing via the Puyallup River out to Commencement Bay.

For the people of King County, the fact that the White River had moved on its own into Pierce County helped alleviate their dismay in the face of the flood's wider destruction. In Pierce County, the arrival of the White simply meant that the flood was even more of an unmitigated disaster.

Despite all the turmoil, the December meeting was amicable enough. The attendees shared, per a story in the Auburn *Argus*, "a determination that the flooding of the valleys should be prevented hereafter, whatever the cost." But elsewhere tensions ran high. Armed guards from King County had been dispatched to patrol the White's new channel for fear that farmers from Pierce County would try to divert it back to its former course. The senators and mayors and landowners and delegates and railroad men in Auburn knew they would have to agree on whether or not to allow the White to remain as it was, and so they convened a committee to study the problem. A few days later the committee met with Hiram M. Chittenden, a major from the U.S. Army Corps of Engineers, to see if he would be willing to help sort things out.

· · ·

Chittenden had been in the Northwest for less than a year as the Seattle district engineer when the committee visited him. A graduate of West Point, he had joined the corps at the age of twenty-five. His assignments had taken him all over the country: to Yellowstone, where in designing the national park's road system he had learned to "contend with man as well as nature"; to Yosemite; and to other major river systems throughout the West. Much of his earlier work had involved flood control and irrigation, and he had arrived in Seattle as the intellectual father of the corps's newer reclamationist leanings.

I imagine Chittenden in Tacoma, listening as the committee told him of the rivers and their sins. He was forty-eight years old at the time, tall and lean, with an erect bearing. His

dark brow gave him a stern visage, and a heavy mustache only amplified a public manner that was, in the words of his otherwise sympathetic biographer, "austere, honorable, and somewhat self-righteous." His focus may have been on loftier goals—Seattle was to be his last post and he was keen to leave a mark—but he thought the committee's request a worthy one and accepted the assignment. The following May he published his findings: *A Report of An Investigation by a Board of Engineers of the Means of Controlling Floods in the Duwamish-Puyallup Valleys and Their Tributaries in the State of Washington.*

Belying its title the report was a slender one, a booklet some thirty pages long. Chittenden's ostensible purpose had been to determine the White River's fate, and that was easy enough. Although, as he wrote, "from 1887 to 1892 there was a good deal of interference by citizens of both counties with natural conditions," all geological evidence supported the theory that the White's native course took it through King County. As to whether the river should be left to its new course through Pierce County or diverted back, he found that the new route was shorter and had a greater slope and so could carry the same amount of water in a narrower channel. "As an engineering question that answer is a simple one," he wrote. "Nature has transferred the course and it will be simpler to perpetuate it than to change it again." Nature in effect had made its choice, but if Chittenden had his way it would be the last choice Nature would make unaided for a long time.

. . .

Folded at the end of the report is a map of the Duwamish-Puyallup valley. It shows the area most prone to flooding, from Sumner to Seattle to Mercer Island in the northeast and Commencement Bay in the south. The White River may have been the impetus for the map—both its old and new channels are shown in the upper right corner—but it is not the main subject. Instead, the Duwamish River dominates the scene.

On the page the Duwamish is relaxed, even whimsical, as it unspools across the valley. Neighborhoods and small towns adhere to its bends and oxbows, subordinate to its curvatures, but civic linearities have already imposed themselves over an otherwise unruly landscape. The Chicago-Milwaukee-Saint Paul, the Northern Pacific, and the Puget Sound Electric railways all run to Seattle right through the middle of the floodplain. The county lines, marked with dashes, are straight but for a few politically expedient kinks, ignoring other perhaps more natural boundaries. There is also a thatch of undefined lines. Are these creeks? Roads? The legend does not say. Whatever they are, they seem to be included as a matter of policy: where there is blank space, there shall be lines.

The Duwamish's freedom, too, is already something of an illusion. Dikes and levees run along almost its entire length, constraining it, or attempting to. Heavy black marks bridge some of the river's most pronounced curves. There are ten such marks. The legend says they are cutoff channels.

In the early 1900s, when Chittenden's cartographer drew this map, work to sculpt the Duwamish around the needs of the city growing around it was well under way. Almost all of what had been two hundred acres of tidal flats were gone from the river's mouth. A growing mound of mud and sand and gravel called Harbor Island was in their place. At the time it was the largest man-made island in the world. On the map it sits poised above the Duwamish like a stopper. Nudge it down just a little and it would plug the river.

Other visions, too: as part of an effort in 1895 to build a canal that would link Lake Washington to Puget Sound, the

Inside Place, or *dxWduW*, formerly an indigenous settle-
ment, now a much-altered confluence where the Black
River's past channel empties a drainage pond

erstwhile territorial governor Eugene Semple had begun to dredge the tidelands for what would become the East and West Waterways. He had run out of money before he could finish, but Chittenden had come to Seattle in part to complete the work. (He favored a more northerly route through Lake Union.) Chittenden saw the Duwamish as subject to these missions of greater import and therefore ripe for correction. "The straightening of the river in the lower stretches of the Duwamish will be of much advantage in many ways," he wrote in the 1907 report, "and ought to be done sooner or later, even if not necessary for the purpose of carrying floods."

Seattleites proved receptive to these ideas and voted in 1909 to create the Duwamish Commercial Waterway District. Engineers proposed shearing almost ten miles from the river via the cutoffs Chittenden had recommended. "The immediate result of lowering the level of Lake Washington and of digging the enlarged Duwamish channel will be to solve definitely the drainage and reclamation problems around the Lake and in the lower Duwamish valley," Chittenden argued in the *Argus* in 1911. "The uncovering of this belt of land around the lakes affords a rare opportunity to protect the scenic beauty of the lake shores and at the same time facilitate industrial growth in situations adapted to it."

On October 14, 1913, work began to convert the final stretch of the Duwamish River into the Lower Duwamish Waterway. Large suction dredges chugged up the river, hungrily sucking up thousands of tons of sediment from the bottom as if through a straw. They sprayed the mud into the nearby oxbows or over what little remained of the tidelands; earth from the regrades of Beacon Hill and Denny Hill was also used as fill. Land accumulated, rebelling against the tides that had once covered it. Businessmen were eager to claim this new terrain. "Acres on acres of low land and marsh land, uninhabitable by anything but fish and waterfowl have become desirable building sites for factories, warehouses or, in some places, residences," read an article in the *Duwamish Valley News* in 1914.

The initial project took four years to complete; work to extend the waterway farther up the river, with turning basins for large ships, lasted into the early 1930s. By the end, twenty million cubic yards of earth had been removed, and the last five miles of the Duwamish ran straight and deep and calm. All that was left of the river's old sinuosity from Elliott Bay almost to Tukwila was a single bend about a mile from the mouth, tucked behind a small comma of land called Kellogg Island.

. . .

Today the best place to see Kellogg Island is from Herring's House Park, across the street from the Duwamish Longhouse and Cultural Center. A former port terminal, the park is a strip of grass and trees bracketed by container yards and chemical factories. All around is the *whish* of cars from West Marginal Way, the metallic screech of the odd train, and the miscellaneous bangings and clashings and grindings and ratchety *clankclankclankclanks* that make up the river's contemporary soundscape.

Paths wend throughout the park. One leads to a bench hidden in a thick rhododendron bush. The island itself is a little more than two hundred feet from the shore below this spot. It is close enough to swim to if one were so inclined. Overrun with vegetation, its trees reach high enough to block from view all but the tallest buildings on the river's eastern shore. It is as if all the fecundity that once ranged across the valley and tidelands has been herded here to this island, where it spills over the edges in a chaotic last stand.

A dozen Caspian terns squabble among themselves on a spit that extends from the island's northern tip. Big, bright,

white, with a rich red bill and black cap, they are vivid creatures in an otherwise drab and scrubby place. A few of them fly over the small span of river between park and island. They track back and forth, heads down, scanning. From time to time one will wheel over and plummet like a dart, biting the brown water. Sometimes it comes up with nothing, but sometimes it emerges with a piece of silver foil wriggling in its bill: a salmon smolt.

As a scene this is almost pleasant: to the island's east, the river that is; to the west, the river as it used to be; between them, a fugitive pocket of wild. But it is like admiring a scab. When people talk of the river today they do so in terms typically reserved for a toxic waste dump, but even if the toxins rightly attract the most attention they will always be the second insult. The first was the straightening. That was what changed the river from a thing in its own right to a means, until the Duwamish was little more than a backdrop for a city and its ambitions.

Chittenden understood the straightening of the Duwamish to be an act of deep transformation and subjugation. At the time of its undertaking it was one of the largest such projects ever attempted anywhere. "It involves the complete change in the route by which a large river is carried to the sea," he wrote at the end of his 1907 report. "The exceptional character of the work may possibly justify the exceptional measures for carrying it into execution."

Reading those words and seeing what the exceptional character and measures and especially their execution have wrought, it is tempting to think Chittenden and his ilk were indifferent to the welfare of rivers. In fact they knew them well and saw their work as necessary care and stewardship. But their empathy had limits. "A form which this conflict between sentiment and utility often assumes is that of resisting changes simply because they destroy old associations,"

Chittenden wrote in 1910 of (and to) those who sometimes objected to the scope of his projects. "It matters little that the change may be an improvement; those who have been familiar all their lives with certain conditions are naturally loath to see them changed."

Thus with the dredge and the dike did Chittenden improve the Duwamish-Puyallup valleys and their tributaries. By digging deep he relieved the rivers of their power, which is motion. With raised and fortified earth he took from them their art, which is erosion. When he had finished the rivers were arranged as we know them today. The White River no longer flows to Elliott Bay but to the Puyallup. The Stuck River is no more. The Cedar River is diked until it empties into Lake Washington, while the lake now drains to Puget Sound from its northern end through the Lake Washington Ship Canal and the Hiram M. Chittenden Locks. The Black River is a trickle of a backwater buried under a grocery store parking lot near Renton. The Green River runs alone until it abruptly becomes the Duwamish, at the ghost terminus of the Black and the White.

What is left is a cubist representation of a watershed: straight lines, edges, fortifications, diversions, one little island, and somewhere within all of that, the Duwamish. "The river glideth at his own sweet will," the poet William Wordsworth once wrote, but that is not true here along this bend of an otherwise unbending waterway: the last curve of the river, the water drifting on by.

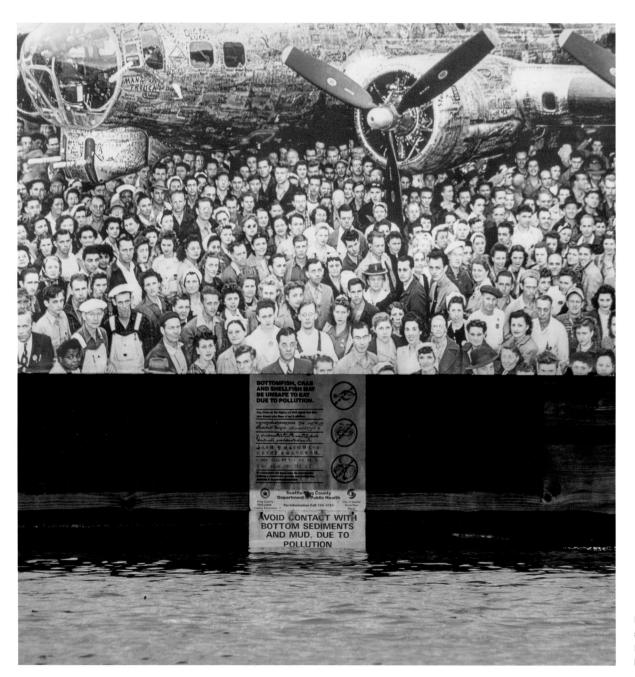

Boeing banner near Plant 2 shows the five-thousandth B-17 produced there, signed by workers

III PLANT 2

Early in 1942, as the United States was entering World War II, a gnawing fear for military officials was that Japanese bombers would appear without warning over the American mainland and wreak havoc. Memories of the attack on Pearl Harbor were still fresh, and Japanese forces were sweeping virtually unopposed across the Pacific. When a small submarine surfaced off of Santa Barbara and fired a few shells at a fuel depot, invasion looked to be all but imminent.

To protect the bases, factories, and shipyards up and down the West Coast, the U.S. Army Corps of Engineers dispatched a specialized group, the 604th Engineer Camouflage Battalion. The commander of the 604th was a slight, bespectacled major named John Ohmer Jr. Born in Ohio in 1891, Ohmer had joined the corps at the start of World War I. After the armistice he traveled to Europe to study camouflage techniques. He would return again to England during the Battle of Britain, marveling at the false landscapes the British erected in empty fields to fool the Luftwaffe. In the United States he sought to re-create their art of martial fakery. He was stationed close to Los Angeles and put together a reserve auxiliary of designers, carpenters, and camera operators from motion picture studios. They built what were in effect huge militarized movie sets.

The Army Corps of Engineers would apply Ohmer's methods at sites from Southern California to the Aleutian Islands. One of the first places they worked at was the Boeing Company's Plant 2 in Seattle. Boeing had built the complex in 1936 for its new B-17 Flying Fortress, lately the U.S. Army Air Corps's long-range bomber of choice. The plant was one of the largest aircraft factories in the world, covering more than forty acres along the Duwamish Waterway about four miles upriver from Elliott Bay. It was so big that it spilled off the land, spreading over the water on hundreds of wooden pilings. Within, tens of thousands of men and women labored to produce as many as sixteen B-17s every twenty-four hours.

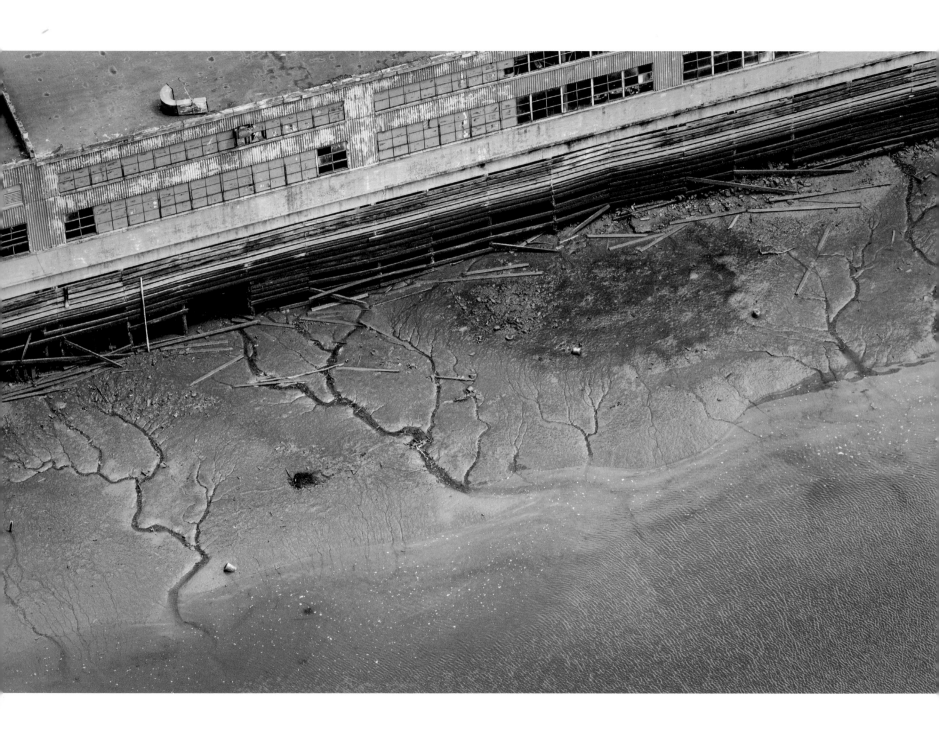

To hide Plant 2 the corps contrived to drape a small town over its roof. Engineers prepared a vast blanket of webbing and covered it with houses made of canvas and plywood, in front of which they parked rubber cars. Green cargo net trees lined streets with names like "Burlap Blvd." or "Synthetic St." Boeing employees would sometimes sunbathe on lawns of green mesh when the weather was nice, or chat over white picket fences that rose to their shins, next to homes that barely came up to their armpits.

The overall effect was remarkable: Plant 2 vanished. But it was an odd vanishing. In old aerial photographs, the neighborhood that sits atop the plant is darker than its environs, its gestalt somewhat askew. That the streets droop at the edges like a melting slice of processed cheese helps stay the illusion, but there are larger dissonances besides. The art of camouflage lies in the seamless blending of an object with its surroundings. If the corps had wanted to hide Plant 2 with features from its natural habitat, then they would have designed the wrap to look like a cement plant or a scrap metal yard. Instead they used a facade of the American middle class—a landscape that had never existed in South Seattle, with its largely immigrant and working-class community.

Plant 2 would make it through the war unscathed, although it was never in any real danger. By the end of the war workers had assembled nearly seven thousand B-17s, and the plant had earned a distinction as the "birthplace for America's airpower" and "one of the most vital buildings in the United States." The camouflaging itself would find a place in news accounts as the years went by. No story was complete without a mention of the time the enormous facility simply disappeared without a trace, and in the end this may have been the most impressive deceit of Ohmer's work: the idea that, on the Duwamish River, something can disappear and leave nothing behind.

Boeing Plant 2 before demolition

. . .

Every polluted river has a business partner, a corporate sponsor. A roster of the country's Superfund waterways is filled with such couplings: the Hudson River and General Electric, the Kalamazoo River and Allied Paper, the Clark Fork River and the Anaconda Copper Mining Company. The Duwamish River has Boeing. As bomber after bomber rolled out of Plant 2's obscured doors, so did a stream of heavy metals (cadmium, lead, manganese, silver, zinc), cyanide, and polychlorinated biphenyls, or PCBs. Oil and generator waste leaked out of pipes or dripped through the wood floors. It leached into the soils and groundwater and oozed down to the river. Every day workers poured up to a thousand gallons of chromic acid waste directly into the Duwamish, a practice that was likely to blame for at least two large fish kills.

I could go on (sodium nitrate solutions) and on (chlorinated solvents) and on (caustics to clean new planes), but it would be incomplete if not unfair to lay the sad state of the Duwamish at the feet of Boeing like a stinking corpse. After the tidelands of the old delta had been filled and the river sculpted into a waterway, the city was impatient to see its new lands put to work. "Cheap Factory Sites in Seattle's Manufacturing Center," proclaimed stationery from the Duwamish Waterway District. "Duwamish Valley's Doing Things." Isaacson Iron Works had opened in the early 1900s, as had the Pacific Coast Steel Company. William Boeing had bought a failing shipyard along the river in 1910; in 1917 he converted that shipyard into Boeing Plant 1, also known as the Boeing Oxbow Plant. Less than twenty years later, as his company was constructing Plant 2, another business, Duwamish Manufacturing, would open an asphalt plant on the opposite shore.

Other companies—paper mills, concrete manufacturers, slaughterhouses, dry docks—helped the new waterway fulfill its intended role as Seattle's Golden Shore. World War II brought further changes. Before, much of the Duwamish Valley had been devoted to agriculture. The twenty-eight acres that Plant 2 originally occupied had been a farm until the owner offered it to Boeing for one dollar if the company would remain in Seattle rather than move to Southern California. Lumberyards and sawmills were also more common, hewing more closely as they did to the area's natural resources. But with the onset of war companies better suited to both aid and profit from the fighting had replaced them.

The consequences for the river were immediate and severe. "The Duwamish Waterways within the City Limits of Seattle receives a larger volume and greater variety of polluting substances than all of the remaining watershed combined," wrote an inspector in a 1945 report for the Washington Pollution Control Commission. "Into the river" would become a dreary refrain, a call-and-response of indifference and neglect on an industrial scale. Almost everyone poured their sewage into the river. Even those businesses conscientious enough to divert their wastes to a treatment plant were thwarted when the plant simply vented its chlorinated effluent into the river. One company, Todd Dry Docks, poured five hundred pounds of acetylene lime slurry into the river every day. ("While it is recognized that, during the existing war emergency, speed in the repair of ships is vital, the extensive and continued spilling of oil into the West Waterway and Elliott Bay does not seem justified," the inspector wrote.) Copper ammoniate, inorganic arsenic, oil, PCBs—for decades the Duwamish received it all, until the river bottom was a carcinogenic swill and the water a fetid mosaic of beiges, blacks, browns, creams, oranges, and reds set against petroleum rainbows.

. . .

Government reports today tend to parse the history of the Lower Duwamish Waterway into three periods. The first is from the early 1900s until the mid-1930s, when the river was straightened and its tidelands filled. The second is from the 1930s until the mid-1950s, with World War II and the rise of industry. A period of relative stasis then follows, from 1955 on. Richard Hugo might have characterized this period best in his poem "Duwamish Head," when he wrote:

> Jacks don't run. Mills go on polluting
> and the river hot with sewage steams.

Hugo's image is one of undifferentiated filth and grime. No one cared what happened to the river, and perhaps that is how things would have stayed had a group of scientists not started studying the water and sediment quality of Puget Sound in the mid-1970s. Working out of a National Oceanic and Atmospheric Administration (NOAA) lab in Montlake, these scientists found a slew of toxins in the mud near the mouth of the Duwamish and fish that were effectively swimming bags of poison. From these findings they sketched clear lines between the different chemicals and the fishes' resultant pathologies, their fin rot and abundance of liver tumors. The general public was shocked to learn of it. That Puget Sound was pristine had been a source of regional pride, but that was apparently not true, and as news of this newer truth spread the response was frenzied. "IMPERILED SOUND!" screamed one newspaper headline. Some opted for more ominous metaphors: "Man's Pollutants Turning Puget Sound into Chemical Time Bomb." Others were simple, direct: "Don't Eat the Fish."

Dredging of contaminated sediment near restoration area at site of former Plant 2

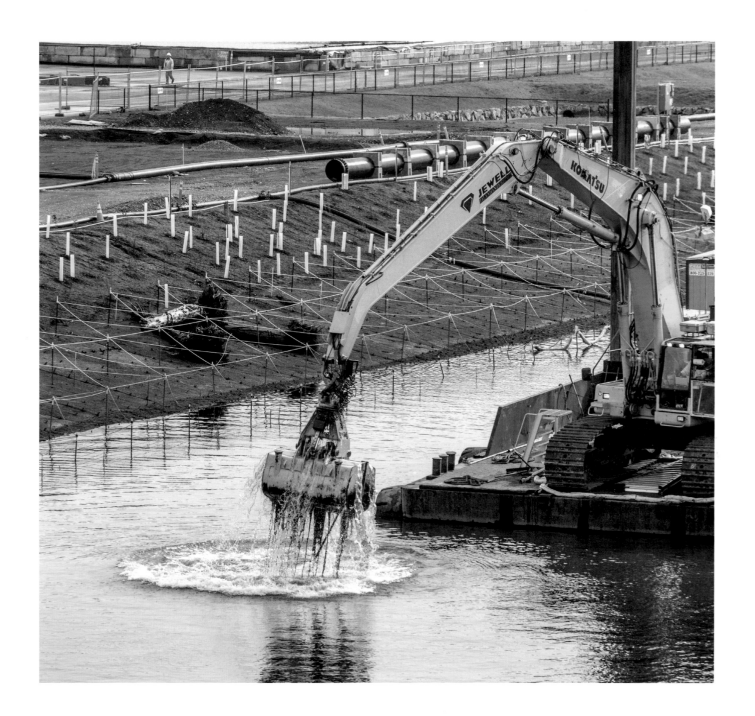

In 1983, compelled in part by the NOAA findings, the state of Washington created the Puget Sound Water Quality Authority, now the Puget Sound Partnership. Seven years later, the federal government filed suit against the city of Seattle and King County for their collective abuses to the Duwamish River and Elliott Bay. Scientists from both the NOAA and the EPA conducted further waterway-wide investigations in 1997 and 1998, respectively. Their surveys generated a list of more than forty contaminants lurking in the surface muds, buried mucks, and fish and shellfish of the Duwamish: dioxins, furans, arsenic, trichloroethylene, carcinogenic polycyclic aromatic hydrocarbons (cPAHs), and so many others. These findings would lead, in 2001, to the EPA's designation of the waterway as a Superfund site.

The toxins most abundant by far were PCBs. Viscous, yellowish, inflammable, stable, and inert, PCBs had been thought a miracle for their wide range of commercial uses when they were developed in the late 1800s. They were soon everywhere: in caulking and grout and paint, in carbon paper, in floor finishes, in tapes and other adhesives, in cable insulation, in polyvinyl chloride pipes (PVCs). No one suspected they might be in any way toxic—the 1945 inspector's report does not even mention them—but now it is well known that PCBs are far from benign. When breathed in, eaten, drunk, or absorbed through the skin, they accumulate in fatty tissues. From there they can cause cancer and birth defects. They suppress the immune system. Children exposed to them for sustained periods can develop learning disabilities or other behavioral problems. Congress banned their production in 1979, but all the things that made PCBs so useful now make them extremely hard to remove. Around 2,300 buildings along the Duwamish corridor contain PCBs in one form or another. The PCBs are so well integrated into the landscape that researchers can detect them in the droppings of Canada geese.

Such a widespread fouling of the river demanded redress. After the Superfund designation, officials faced the task of prizing apart the river's blend of toxins so they could identify, in the capitalized argot of the Comprehensive Environmental Remediation, Cleanup, and Liability Act (or CERCLA, the formal title of the Superfund law), the Potentially Responsible Parties. Businesses large and small were culpable, but some more than others, and not all the parties existed in a punishable form anymore. By dint of their size and the extent of the pollution that could be attributed to them, four principal entities became the focus of the EPA's regulatory attentions: Boeing first among them, followed by King County, the city of Seattle, and the Port of Seattle, as the supervisors that had presided over the river's deterioration and done so little to stop it. In 2000, those four would form the Lower Duwamish Waterway Group, compelled by the EPA and the Washington State Department of Ecology to study the extent of the river's contamination and the risks posed to people and wildlife.

Apportioning moral blame was easier than determining exact liabilities. Even as Boeing offered to clean up the pollution from Plant 2, the corporation lobbied hard to limit the extent beyond that for which it would be accountable. Given the nature of a river, who could say with any real certainty where this or that molecule had come from? The EPA accused Boeing of shirking its responsibilities and drawing arbitrary lines in the water, in the mud. Boeing demurred. It would pay for its own mess but not other people's messes.

The debate spread to the methods of cleanup. With its group partners Boeing argued that the intensive dredging necessary to remove all the toxic sediments—a strategy community groups favored—would not only be too expensive, but also not guarantee the river's cleanliness. Regardless of what the company did or did not do, thousands of

tons of pollution would still flow into the river from surrounding neighborhoods after every rainstorm as runoff. No one had figured out a way to control that, so why spend so much to clean a place that only gets worse every time it rains in Rain City? Lawsuits followed. After pollution itself, litigation tends to be the most common feature of a Superfund site.

Following more than a decade of haggling and study, the EPA released its cleanup plan near the end of 2014. Called the "Record of Decision," it was as most such documents are an attempted compromise between idealism and pragmatism. To those who protested that the plan did not do enough, the government's response was akin to a tired if exasperated shrug: no one is superhuman; there is only so much anyone can do with such a contaminated place.

If all goes as intended, the plan will reduce PCB levels by 90 percent over the next two decades. The work will take at least seven years and could cost more than $340 million. (For the sake of comparison the federal government spends $500 million each year to bolster salmon stocks on the Columbia River.) Of the 412 acres within the Superfund boundaries, the EPA (or Boeing, or the Port of Seattle, or the city of Seattle, or King County) will work to clean 177 of them: to dredge them, that is, or to put blankets of clean sand, called caps, over them to trap the dirty sediments. The rest—235 acres—will be left to what the EPA calls Monitored Natural Recovery. This means that EPA and state officials will watch and wait as the river goes about its business. They will trust the reduced flow of its deepened channel to carry the most dangerous sediments out to Elliott Bay, where the toxins will pose less of a risk to people; or they will bury them under a natural blanket of fresher muds borne from the Green River, which is not that much cleaner than the Duwamish.

A curious gambit, to ask the river to heal itself. It will be interesting to see whether this last, most ill-treated stretch of the Duwamish can behave like a river once more when it is so long out of practice. It will be interesting to see whether, as a river, it has anything left to give.

．　．　．

Plant 2 is gone now, torn down in 2011. Even as the EPA and the Lower Duwamish Waterway Group squabbled over the details and extent of the final cleanup plan, they all agreed (or were made to agree) that some parts of the river were simply too poisonous to let lie. These became Early Action Areas—places where the Responsible Parties would address the pollution even before they settled on a larger course of action. There are five such areas in the Duwamish, and Plant 2 is generally understood to be the worst of them.

At the prospect of the plant's demolition, a few people complained that the city was being too quick to toss aside a hallmark of its industrial history. "Tearing down that historic building is just another load of dynamite under our dying culture," wrote one reader to a magazine, but for Boeing the end of Plant 2 came as no great loss. Engineers had stopped assembling planes there many years before. The old buildings had become administration offices or places to stash unused furniture. There was some light manufacturing work, some small research projects, other miscellany. The Museum of Flight leased most of the empty acreage to store its old planes.

As part of its settlement with the EPA Boeing agreed to restore a five-acre section of Plant 2's former shoreline. Workers dug channels and installed several hundred thousand plants and shrubs to mimic the functioning ecology of a river. Piles of logs simulated dead trees, laid across a small, kinked side stream that juvenile salmon could rest in on their way to Puget Sound.

Seen from the height of the new bridge in South Park, the disguise is quite convincing. Although this newer marsh does not blend in seamlessly with the asphalt parking lot and factories at its edges, looking at the grasses and shrubs you would never guess that they hide an airplane factory. For Plant 2 is still very much here. It will be here for a hundred years, a thousand. Maybe that is why, again and still, the camouflage looks out of place.

Spawning habitat for salmon on
Hamm Creek created by John Beal

IV HAMM CREEK

A couple of Saturdays each year, the public is invited to visit one of several sites along the Duwamish River and spend the morning cleaning it up. These Duwamish Alive! celebrations, as they are called, serve to remind those of us who wish to be reminded that the river will always be here and in need of care. Hundreds of volunteers might come, and some sites are so popular that people have to be turned away. The estuary at Hamm Creek is not one of them. To call it humble flatters it: an open field just off West Marginal Way, it lies between a Seattle City Light substation and a manufacturer of luxury yachts. On this early spring day, gray and assured of rain, only ten people are here.

Standing before us with an optimistic number of shovels is Jeremy Grisham from the Veterans Conservation Corps. A navy medic for more than a decade before joining the corps, Jeremy is a tall, burly fellow with big arms and a bushy, expansive beard that seems a touch defiant given his military background. In his large brown coveralls, with his earrings and a cap jammed low over his eyes, he would be an intimidating figure if he wanted to be, but he has a soft voice and gentle manner. He waits patiently while people get out of their cars, drink their coffee, natter themselves awake. (It is early.) Then he notices some children running off through the grass. "You might want to call your kids," he says. "Homeless people come here, and we've had issues with the stuff they leave behind."

Their parents nod and keep nattering.

Jeremy tries again. "People drink and do drugs out there," he says, "and they sometimes . . ." (he searches for the proper words) "leave things behind."

Still no one does anything.

Jeremy dispenses with euphemism. "I'm talking about broken bottles and used needles and maybe human waste."

At this the parents hail their children, call them urgently. The children scamper back, laughing.

"Thanks," Jeremy says. He leads us to the trees that frame

the field. We cross tire tracks, beaten ground. Swallows cut paths through the air around us; I hear the occasional light *tic* as one snaps its bill on a luckless insect. We follow a narrow trail through the trees to the riverbank. Hamm Creek drains to the Duwamish out of a dense, shrubby wall. The tide is low, the grasses sodden and bent. Pilings jut out of the mud like broken teeth. Out over the river two ospreys are coursing back and forth, but there are no fish right now and they fly off elsewhere.

We gather around Jeremy. He pulls a sheet of paper from his pocket and unfolds it. "Before we get started," he says, "I want to tell you a little about John Beal."

• • •

That anyone has ever heard of Hamm Creek is largely due to John Beal. Born in Spokane, Beal joined the marine corps when he was eighteen. He was sent to Vietnam early in 1968, at the start of the Tet Offensive. He was wounded three times and returned home a few months later. He and his wife settled in South Seattle, in South Park, and for the next ten years he repaired televisions, sold security equipment, did any number of odd jobs. Life was hard. Besieged by memories of what he had seen and done, he suffered from posttraumatic stress disorder. He had his first heart attack when he was only twenty-eight. Within seven months he had had two more. After the third, doctors diagnosed him with heart disease. Without surgery, he was told, he would likely be dead within a few months.

What happened next would become a fixture in the contemporary lore of the Duwamish River. Distraught, Beal went to Hamm Creek, a small backwater that began near the town of White Center and porpoised in and out of daylight via a network of culverts and ditches before a pipe finally spat it into the river. The stretch near Beal's home was a reeking

stew of oil and garbage. Beal saw obvious parallels. With whatever time he had left he vowed to make the creek whole again.

He started hauling away all the trash he could—refrigerators, computers, old tires, paint cans, busted household appliances. Once he had cleared the creek he started trying to coax back the vegetation and animals that had left it, planting the former unofficially, releasing the latter surreptitiously. Slowly, and after years of being written off to ruin, the creek revived. In 2000, at Beal's urgings, engineers freed its last half mile from the culverts and pipes, redirected its outflow south a few blocks, and built this estuary for it. By then Beal had expanded his efforts to include the Duwamish itself. He bought a small boat and took to the river, sometimes with sandwiches and a case of beer, motoring around in search of the most flagrant polluters, threatening to sue them if they didn't clean up their act.

Beal worked mostly on his own at first, using what little money he had. As he toiled away his work gained first local, then regional, then national attention. He found himself a minor celebrity of sorts, regularly profiled and feted: the Vietnam vet who had no formal training but refused to let Hamm Creek die. Politicians would visit the creek and laud him while he stood off to the side with his hands jammed in his pockets.

When his profile grew Beal tried to ensure that others might benefit as he had. He helped to push a bill through the state legislature to found the Veterans Conservation Corps. Testifying before the state senate in 2005, he said that when he returned from the war he was a "wreck" and "completely broken." His commitment to Hamm Creek had given him purpose and even brought him extra decades of life. The bill passed, but in 2006, before the corps could be officially formed, Beal died of a heart attack. He was fifty-six years old.

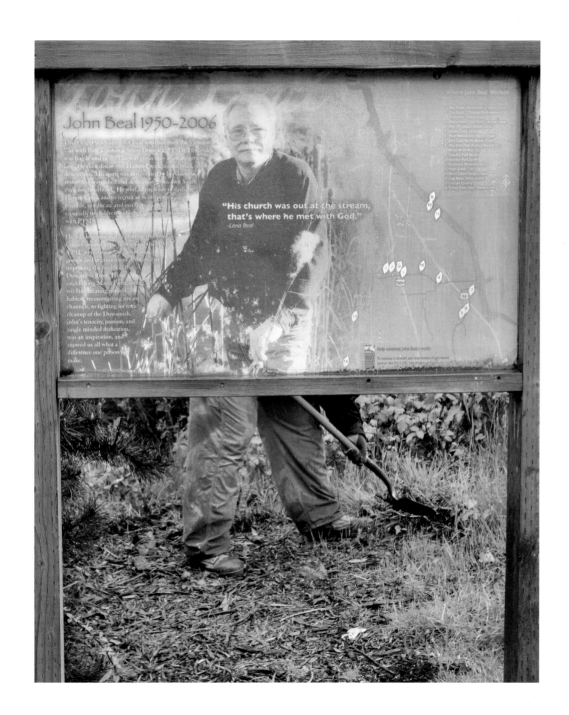

Volunteers continue work
at Hamm Creek

· · ·

The rain arrives as Jeremy leads us back to the gravel lot. An imposing pile of mulch awaits us. For the rest of the morning, we are told, we will clear the weeds and blackberries from the verge and spread the mulch around some newly planted shrubs. At this prospect of manual labor in a downpour our number abruptly drops to four. "We're sorry, we weren't prepared for this!" the deserters cry as they scuttle to their cars. Jeremy watches them leave. Like them, he had envisioned the day going differently. "I was hoping we'd have some time before we work to sit and think about what the Duwamish means to us, you know, and maybe write a little poetry," he says, shrugging as fat drops spot his coat. "It doesn't look like the weather is on our side today."

We who remain set to work ferrying mulch or hacking the weeds. The blackberries especially have a grim grip. I beat at them with the blade of my shovel and, in trying to sever their roots, mutilate the earth. Although this element of restoration tends to be glossed over in favor of gentler, more curative scenes, an initial paroxysm of violence is as much a part of the project as anything else: the corrupting life that was carrying along quite nicely on its own—the invasive plants and animals so good at taking advantage of the conditions we create for them—must be vigorously dispatched to make room for more preferred communities.

The verge itself is modest: a narrow path, the short shrubs, and a small, faded sign with a map of Hamm Creek and a picture of John Beal. He stands among some cattails, unsmiling. Grimacing, in fact, which makes him look pensive and wary, worn with care, even a little sad. He holds his hands in the way of someone using a walker, as if hoping the cattails might support his weight.

In the middle of the sign is a quote from Beal's widow, Lana. She was here earlier in the day, graciously nodding when Jeremy introduced her. She seemed far too young to have already been a widow for eight years. She said that John spent decades battling state and federal agencies, trying to get them to do their jobs. When they wouldn't, he did.

Her quote on the sign reads, "His church was out at the stream, that's where he met with God." Many environmentalists flirt with the rhetorics of religiosity without actually assuming the mantle, but Beal had embraced his story's biblical resonances. He was a man in despair who had gone to the wilderness, or the nearest approximation of it he could find. God spoke to him there from a sickened stream. Henceforth, his life became a sermon. One author wrote that visiting Hamm Creek with Beal was like going to church. Another called him an environmental saint.

The rain falls cold and heavy and straight down. It overwhelms chitchat, driving us into the quiet interior spaces of thought. Was John Beal a saint? A lively apocrypha certainly surrounds his work. Someone tells me that Beal would sneak out at night and, under cover of darkness, dig up parts of Hamm Creek that were buried under asphalt. I later find an article in an old *Reader's Digest* that recounts how a fisherman had once given Beal two coho salmon, a male and a female. He released them in the creek but they died without spawning, so he took the female, slit her belly, and spilled her eggs in a redd he had dug by hand. Then he went farther up the creek and squeezed the male, sending out a thin, milky string of milt. The water carried it downstream to fertilize the eggs. A few weeks later, young salmon filled the creek.

The account is affecting, but sometimes the resolve to bend Beal's story to a desired end becomes too evident. I read in another old newspaper article that his work resulted in one million smolts using the creek. This strains credulity. One million smolts would mean at least one million eggs. A female

Cabins in the neighborhood of River-
side, West Seattle Bridge above

coho has, on average, about 2,400 eggs. One can be conservative and still must concede that one thousand coho salmon do not spawn in Hamm Creek, and probably never did. (In 2001 biologists counted three spawning pairs.) But the inflation is understandable. In the imagined landscapes of the Duwamish River the redemptive arc has a powerful allure. It feels good to say that, thanks to one man, what was once a sewer of a tributary now runs clear and full of salmon—certainly better than it feels to say that a marginal space was improved somewhat but is still not without major problems. Such embellishments say more about our needs than those of Beal, whose criteria for success were not necessarily our own. I think of an alternative reading to his restorations:

> The cruel things I did I took to the river
> I begged the current: make me better.

· · ·

These lines are from "The Towns We Know and Leave Behind, The Rivers We Carry with Us," a poem by Richard Hugo. Hugo grew up in the town of White Center, not far from Hamm Creek's North Fork. By his own account he had a miserable upbringing. His mother left him with her parents when he was eighteen months old; she had given birth to him when she was just seventeen. Hugo's grandparents were German immigrants who had moved to White Center from Michigan. When they weren't beating him or threatening to throw him out of their house, they were, as he would later write, "silent people who communicated little, and who left me to my own devices for hours."

Hugo spent many of those hours in a nearby forest. Deep in those woods were three small depressions in the dirt that would periodically fill with rain. Hugo liked to fish in them with twigs, or float fern boats across them, or sink small bark

submarines in them. The ponds held a darker appeal, too, as a kind of base elixir. "I used to drink the rain water because I believed it was 'poisoned' or 'diseased' and that by drinking it and not getting sick, not dying, I could successfully defy whatever in the world might threaten to destroy me," he wrote. "I drank water from ponds, swamps, and ditches to prove my immortality, but I told no one. My immortality was my secret, shared only with water."

Bodies of water feature prominently in all of Hugo's work, but especially in his earlier poems. In his younger verse he visits rivers throughout the state. The quick, clean ones like the Skykomish or the Hoh were attractive in their way, with their "water off for heaven" and so on, but it was the dirty, impure waters that spoke to Hugo most strongly. Only they could offer the kind of everlasting life he was interested in, no matter how profane it might be, and when he was young (and for that matter up until the time he died in 1982), few bodies of water were dirtier or more impure than the Duwamish River.

Hugo drank deep of it. Read in succession, his Duwamish poems pound out a larger aesthetic statement on the nature of dreariness. A host of marginalized and desperate characters crowd the river's cruddy banks: drunk Indians, drunk salmon fishermen, cruel children, Slavs fermenting fruit to make liquor, the bloated carcasses of drowned dogs, the specter of a murdered woman, and "the Greek who bribes / the river with his sailing coins" and needs no formal introduction. These characters made up Seattle's underclass: the immigrants and the working poor, purposefully shunted to the river and kept away from the shining hills of the city proper. Of course there are hardly any salmon. Only their shades survive under "a fishless moon."

Past all of them, all of this, the Duwamish slugs along. Its squalor would become Hugo's rude material, something

Water strider on Hamm Creek

he could sink himself into, and he was grateful to do so. "The river helped me play an easy role— / to be alone, to drink, to fail." As someone who chastised himself as soft, Hugo found at the Duwamish River a way to become his better self, at least as he envisioned that self, with failure as an angry, defiant little spore. "I always wanted to be tough, like those young men who lived near the river and came to White Center to fight, and in my poems I could get tough, at least with myself," he wrote. "Once I imagined myself along the river, my language got hard and direct."

More than any gritty realism this imagining was key for Hugo. His autobiography, *The Real West Marginal Way*, stitched together after his death by his widow and editor, begins, "In many of my early poems, the speaker is, I am, somewhere along West Marginal Way, the slow lower reaches of the Duwamish River, the last two or three miles before the river ends in Elliott Bay, Puget Sound. Reading these early poems, one might think I spent much time in that area and had an intimate knowledge of the place, but that's not true." It was an idea of the Duwamish that captivated him more than the thing itself. Again and again, he (or the speaker) returns to this invented river for the perverse succor only it can provide:

> I come here to be cold. Not silver cold
> like ice, for ice has glitter. Gray
> cold like the river.

But the river is a brute space steeped in misery. It has little use for Hugo's self-pity. It dismisses him, informs him, coldly, "you're not unique." Then it sends him on his way.

. . .

The mulch pile seems to swell with the rain. Our shovels slide into it and come up full of dripping mush. Each shovel-ful must weigh ten pounds. We lug the hacked-up fir chips to the verge and dump them, spread them out. Lug, dump, and spread; lug, dump and spread. No one says anything, and in the clammy gloom I wonder what will have really changed when we are done. The answer is not heartening. About forty square feet of the verge will have a new layer of mulch. We will have beaten back some of the more aggressive blackberries. (They are sure to return. Blackberries always do.) Otherwise, not much will have changed at the site itself, and for the river our work certainly means next to nothing.

The rain eases. It seems to know that it has won, that we will soon be leaving. What has changed? The question rises like a low fog out of the minor cosmetics of the verge and creeps over to the brown creek that drains into the brown river. One historian, writing on the place of the Duwamish in Seattle's history, remarked that the river Beal knew had changed significantly from the one that Hugo grew up on. Of this I have my doubts. True, some of the details were different. In the 1920s and 1930s of Hugo's childhood White Center was a rough, working-class town of mostly European immigrants. Now the immigrants may come from other countries on other continents, but the neighborhoods are still among Seattle's most impoverished. The Duwamish also probably was not as developed as it was when Beal started his work, and the factories along its banks bore different names. These seem to me trivial, academic differences. The relationship the city would have with its only river was fixed long before Hugo and Beal were born, and it would endure, unchanged, for decades. People dumped trash in the river then. People dump trash in the river now.

"Okay, let's call it a day," Jeremy says. "I think everyone is miserable enough."

The biologist William Jordan has argued that restorationists, having the unique ability to bring certain kinds of

landscapes back from the dead, bestow on those resurrected terrains what he called ecological immortality. This is a type of cultural immortality in addition to being a biological one. "The higher level of self-awareness it represents," he wrote, "is the restorationist's real gift to nature."

Jordan would seem to see the gift as selfless and for the most part unidirectional, but really it is a reciprocal act. Whatever small things we did or did not do here today do not matter so much as the legacy perpetuated through the ritual of exchange. Both Hugo and Beal came to the Duwamish and embraced it as a means to extend their lives. In that they succeeded. Restless ghosts, they will linger here forever. As long as the river runs we will see it through Richard Hugo's eyes, even if we do not know it. As long as there is a creek named for Duwamish Waterway commissioner Dietrich Hamm we will have a reminder of John Beal's pain, even if we never felt it.

I lean my shovel against Jeremy's truck, peel off my sopping gloves, and drop them in the bed. They land with a dull, wet *shlap*. Jeremy offers me a bag of corn chips and a small apple and waves goodbye as he pulls out. Food in hand I walk back to the river, taking care, now that I know of it, not to impale myself on any of the sordid junk stashed about the field. When I get to the banks I see that the ospreys have returned from wherever they were. They perch next to one another on the tall nesting pole erected for their benefit, a picture of bedraggled domesticity.

I stand on the bank and face the river. Swarms of small flies have filled the air. Apparently there has been an insect emergence. Mayflies, midges—I can't tell what they are, but I watch as they drift out over the river in a loose cloud of entomology. The slow rising heat and bleached midday light combine with the spreading visual static of the bugs to create a soporific effect, and the scene is becoming hazy when a large salmon suddenly hurls itself from the river. Its appearance is blunt, shocking. Leaping again, it commands my attention. Maybe the flies would not be here if no one had planted the vegetation when the creek was restored. Maybe as they hover over the water the flies have attracted some species of smaller fish, which may have in turn attracted this salmon. Maybe I am not privy to all the ways a minor gesture can pass through the land or ripple across the water. The salmon leaps once more, thrashing through the air. When it falls back into the river, the *slap!* of its splash is like a rebuke.

V TERMINAL 117

Consider the asphalt shingle. Most often black, brown, or gray, but sometimes green, or even blue. Rectangular. Twelve to eighteen inches wide, and thirty-six to forty inches long. Developed in the late 1880s. The most widely used roofing cover in North America. Found on over 80 percent of homes in the United States. Probably above you right now, on the roof over your head.

To make a shingle—to make a million—take a big roll of organic felt. Feed it through a dry looper. Submerge it in hot asphalt. Let it cool. Add a thick layer of ceramic-coated mineral granules to the top. Dust talc on the back so it will not stick to the other shingles. Cut it. Pack it. Ship it. Nail it down, row after reassuring row.

Asphalt, sometimes called pitch or bitumen, can occur in natural seeps, but most of the stuff used to manufacture shingles comes from the distillation of crude oil. It is essentially a by-product. After the petroleum gas has been burned

away and collected, after the naphtha, after the gasoline, after the kerosene, after the diesel, after the lubricating oil, after the heavy fuel oil, all that is left is a black sludge at the bottom of the barrel: asphalt.

In 1937, a company called Duwamish Manufacturing opened a plant to produce roofing asphalt along the Lower Duwamish Waterway. Sited just across from Boeing's Plant 2, it sat on one of the last curves left on the river after its revising. Duwamish Manufacturing produced asphalt until 1978, when it sold the plant to Malarkey Asphalt Company. Malarkey operated it until 1993. The plant was torn down three years later.

Taken as one of many businesses along the river, Malarkey Asphalt, which became the site's common name, was unremarkable. The company was never the subject of a lawsuit or accused of any criminal wrongdoing. By the standards of the Duwamish it was ordinary, and in that ordinariness, instructive. To sift through its leavings on the land and in the

Perimeter of Terminal 117
Early Action Area

water, to learn how they got there and how people responded or did not, is to confront the questions at the heart of the river's cleanup and restoration. How did the Duwamish become so polluted in the first place? What mechanisms will we use to address that pollution now, after so many years? Is it possible to clean up such an unclean place? Is it practical? Is cleanliness even the final goal? If it isn't, what is?

• • •

Polluted lands want no history. History means ownership, ownership means responsibility, and responsibility can cost a lot. With the asphalt plant, official documentation is hard to come by. Much of it has disappeared, and what little remains is cryptic and scattered. Aerial photographs from surveys done many decades ago show buildings and storage tanks sprouting up like toadstools around the site, only to vanish as other structures take their place. A contractor's report from 1992 states that the U.S. government used the property in the 1940s, but no one knows why. Also it has been reported, the report reports, that in the 1950s the U.S. Army Corps of Engineers might have dumped dredge spoils from the waterway's maintenance along the shore. Those spoils might have contained heavy metals, as did others deposited in the 1970s.

Once Malarkey Asphalt bought the plant, the company came under the sort of scrutiny that starts to leave a paper trail. Now we know the plant used flux oil from a refinery in Richmond Beach as a fuel source. We know Seattle City Light helped keep the plant running during the Arab oil embargo in 1973 by providing one thousand gallons of used transformer oil every month. We know Seattle City Light continued to do this for fifteen years. We know plant workers sometimes sprayed oil over the streets of South Park to keep the dust down.

All of this we know because in the early 1980s, city, state, and federal officials started to look at the Lower Duwamish Waterway with an eye toward cleaning it up. At Malarkey Asphalt the first inspection came in 1984, when investigators from the Municipality of Metropolitan Seattle, or Metro, took samples from the land and the river. They found that PCBs, cPAHs, and zinc had spilled on both, and in the river at levels well above state water quality standards. They also noted the presence of a holding pond that would fill with oily discharge during heavy rains and overflow directly into the Duwamish.

The investigators recommended further investigation.

Reports accrued. In 1985 and 1986, inspectors for the state Department of Ecology found elevated levels of lead, arsenic, zinc, and cadmium in a drainage ditch. They noted "visibly stained surface soil" in spots. They recommended further investigation pursuant to a fine, but the plant owners pleaded financial hardship so no subsequent work was done, nor was any action taken.

On it went. Between 1989 and 1990, the EPA visited the site three times. The first time inspectors found high levels of halogenated hydrocarbons in waste oil tanks. The second time they observed that those tanks had no means of secondary containment should they ever fail, which appeared to have happened in the past. The third time inspectors registered the presence of, but took no samples from, three underground storage tanks for gasoline and diesel, one ten-thousand-gallon waste oil storage tank, three more underground storage tanks for waste oil, a railroad tank car with waste oil, and two waste oil tanks that were partially buried.

After the third visit investigators recommended further investigation.

In 1991, the Department of Ecology returned, this time to perform a Site Hazard Assessment, or SHA. As a prelude to

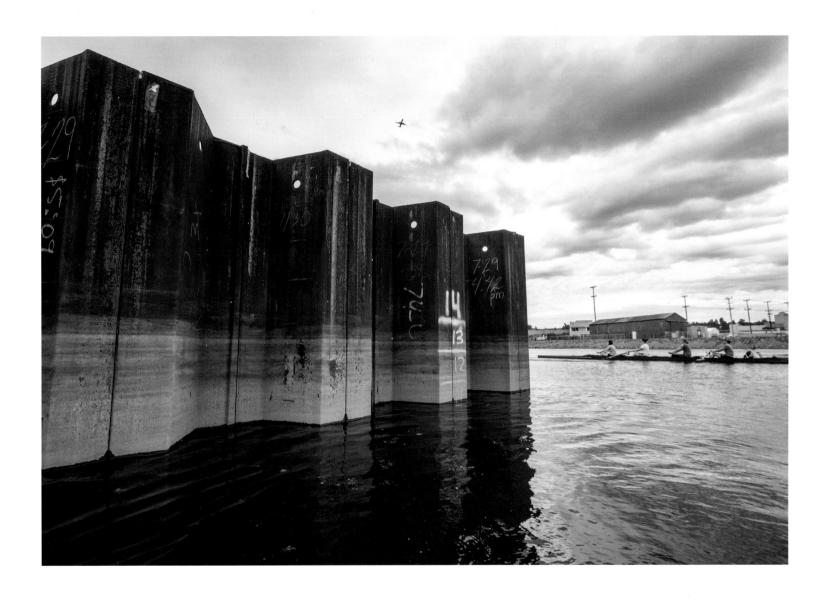

Cleanup work behind metal dam seeks to transform
T-117 into a site sufficiently clean for public access

a much more intensive cleanup, an SHA determines the relative risk a site poses to human health and the environment. Once it has been done, the site goes on the state's Hazardous Sites List and officials rank it on a scale from one to five, with one being the most severe. In the case of Malarkey Asphalt officials installed three monitoring wells, sampled the groundwater and soils, and tested the contents of the various storage tanks. They found that PCBs, cPAHs, dioxins, heavy metals, volatile organic compounds (VOCs), and semivolatile organic compounds (SVOCs) had leached into the soils up to six feet beneath the surface. All of these plus pesticides were present in the groundwater. Malarkey Asphalt thus earned a rank of one: it was among the dirtiest, direst threats to public health in the state of Washington.

With that, dealings at the site took on an air of valediction. Contractors decommissioned a few of the storage tanks in 1992, as well as the railroad car. Those tanks not slated for use elsewhere were filled with concrete slurry and the railroad car was hauled away. A year later the factory produced its last asphalt. Demolition of the plant began in 1996. (It had taken some time to sort through problems with asbestos.) By 1998, the entire plant had been torn down and carted off as scrap. In 1999, the Port of Seattle bought the land and consolidated it with a neighboring parcel, which it already owned. This larger area would become Terminal 117, or T-117.

The asphalt plant may have disappeared, but it was loath to release its hold on the land. Sampling later in the year found PCBs still at unsafe levels, so the port, with the EPA supervising, removed over two thousand tons of contaminated soils. The work ended in February 2000 and the EPA sent out a press release a month later that proudly proclaimed, "Cleanup Completed!" To round things off, the port contracted a company to lay a fresh layer of asphalt over the site. Naturally.

• • •

Shortly after, the port put the land up for sale. A prospective buyer wished to expand his own business just north of T-117 and made an offer. One day he watched as a pair of technicians drove up to the site. The two men got out of their truck and appeared to inspect a drain. As the would-be buyer told a reporter from the Seattle *Post-Intelligencer,* "They looked down in there, took a sniff, and literally jogged back to the truck to get their moon suits." He received a message from the port a few days later telling him the land was no longer for sale. The timing was apparently a coincidence.

This was the first of several surprises to come from T-117. In 2003, a pair of activists from the Duwamish River Cleanup Coalition, a group then just two years old, was walking along the shore below the site when they found a few large industrial drums lying among the rocks. One of the drums was dripping orange gunk. The gunk was rife with PCBs. That same year the EPA listed T-117 as one of its Early Action Areas. Local advocates were already skeptical of what they felt were the overly modest aims of the initial cleanup work. They requested additional surveys of the site and, more importantly, the streets and alleyways around it. The results were grim: PCBs were everywhere, and in concentrations far greater than anticipated. In some areas their levels were more than ninety times what was considered safe.

Officials from the EPA, the city of Seattle, and the port were shocked, but South Park residents had complained for years about the oily black dust that coated their homes and yards. They were now assured that they had nothing to fear. PCBs may cause cancer in rats and have serious reproductive consequences for rhesus monkeys, but exposure to contaminated soils was not, in the words of one city official, "as significant as, say, eating contaminated fish." Public health workers

Access for contaminant testing near T-117

went door to door regardless, advising people to wash their hands, wear gloves when gardening, and take off their shoes before entering their homes. The port pledged several million dollars for a rapid cleanup of the neighborhood. (Officials estimate that the entire cleanup of T-117 will cost around $33 million.) Workers dug up all or part of eight different yards and excavated two alleyways, removing the soils and replacing the gravel. They repaved some of the streets.

Meanwhile, the excavation of contaminated soils and demolition of the few remaining Malarkey Asphalt structures continued. In August 2013, workers digging through the site came upon two underground storage tanks and forty drums filled with unknown liquid waste. No one had had any idea that anything was still buried. Also, the drums were leaking. "Although the T-117 site was investigated thoroughly before cleanup began via 250 borings, ground penetrating radar, and other methods, these unexpected materials were still discovered," a project update read. "Most of these product-filled barrels were found under the riprap, or the large rocks and rubble protecting the river bank, making these materials difficult to locate."

The cleanup of the land was finished early in 2014. When I drop by these days, the site is blocked off by a chain-link fence. Posted signs say, "Do Not Enter! Keep Out!" This seems like good advice, even though T-117 has now, again, been declared clean. Then I recall what it took to get to where I can look out at an empty gray lot: the pageantry of inspections, the interchangeable metonymic government agencies, the pages of spreadsheets, the reports written to anesthetize, the theme-and-variations of the findings, the carcinogenic acronyms and their precise physiological targets (the breasts, the liver, the lymph nodes, the poor and disenfranchised). It all seems so tedious, and in that tedium, terrifying. The mind absorbs reams of information the way the ground ab-

sorbs spilled oil: the stuff sinks in, leaves behind its stink, its residues. I remember also that Malarkey Asphalt is just one site of many. Its circumstances repeat all along the shores of this Superfund river, its history as black as pitch.

· · ·

On a brittle morning in February, made worse by the wind, a small motorboat flies over the smooth cellophane of Elliott Bay. Behind the wheel is George Blomberg. He has a long, thin face that the cold has burnished well past red, almost to purple. He wears a smart blue beret but no gloves. His fingers look like they might snap off. (He says he can't feel them.) Otherwise, he seems to be enjoying himself. In the front of the boat Kym Anderson huddles on a bench, fortified in coat, hat, scarf, gloves. She clasps her arms around her knees. Her hair is loose and whips across her face.

We pass Harbor Island and turn up the river. Blomberg is an ecologist, Anderson a senior environmental program manager. Both are with the Port of Seattle. We are on our way to T-117 to watch the port's contracted dredge haul up some of its daily allotment of PCB-rich sediments from the river bottom. During this stage of the Early Action cleanup work eight thousand cubic yards of mud are being removed. Fourteen thousand cubic yards will be gone by the time the project is done, replaced with tons of clean gravel and sand. (Anderson says that from the entire Superfund site more than nine hundred thousand cubic yards of sediment will eventually have to go.) Dredging started last December and Blomberg says it is going well. He steers past a tug as it lumbers in the other direction. Barges crowd this part of the river, which hosts a gathering of Early Action Areas: on the eastern bank are Slip 4 and Plant 2 and Jorgensen Forge, all within a few hundred yards of one another; on the western bank, T-117.

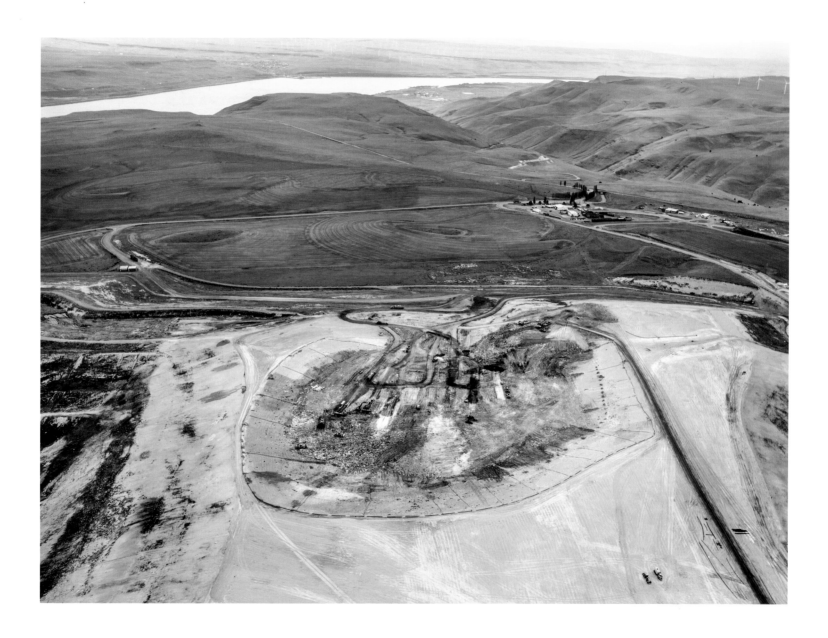

Near the Columbia River, the Roosevelt Regional
Landfill in Klickitat County receives sediment
dredged from the Duwamish

We reach the site and Blomberg slows the boat. When planning the initial cleanup, the port and the EPA wanted to treat T-117 like an industrial area as it had been treated before; standards of cleanliness for an industrial area are less stringent than they are for a recreational area. Residents of South Park protested. They wanted to integrate the land back into their community. The EPA relented. The cleanup would therefore cost more and take longer, but it would also broaden T-117's aesthetic possibilities. This is why, instead of ruminating over the huge rusting steel barrier that skirts the site to keep contaminated mud from running into the river, Blomberg can see a vegetated, channeled, salmonid future. His are bright visions. "We're going to put in a boat launch for small boats, and a pier, and dig channels in the mudflat," he says. "Salmon will have refuge there and also along the bank."

Anderson listens, nods, smiles. A chemist by training, on this day she is more mired in T-117's complicated present. "This part of the river was Seattle's toilet," she says. She claims not to be a pessimist but a realist, and as a realist she is obligated to concede that, like the rest of the river, T-117 will never be fully clean. "The water is dirty when it gets here," she says. It is a thorny issue. The Superfund work centers on the Lower Duwamish Waterway, and that is logistical challenge enough. But a river is not a static entity. Water is everywhere, always moving, always transporting. What to do about the rains that cascade down the streets as runoff into the river every year, bearing over one hundred thousand tons of motor oil, gasoline, dog feces, and fertilizer? What to do about the pollution that drifts from Auburn and Tukwila and the Green River into the Duwamish River and on to the waterway? Who in the end is responsible for all of that? Everyone and no one.

Blomberg steers around the barges. There are four and they are paired: one is a platform that holds a gigantic float-ing crane, and the other is a tub into which the crane can dump its slop. One of the pairs is in front of T-117 while the other works off Plant 2. As we get closer to the big tubs, the air becomes perfumed with the putrid stink of anaerobic muck.

We drift around the crane working T-117. Its boom reaches to the heavens like the neck of a brachiosaurus, so high it almost blocks the sun. The contractors, Blomberg says, are in a hurry to finish as much of the job as possible within the current fish window, which will end in a few days. Work will then have to stop for a couple of weeks when the probability of young salmon migrating through the waterway increases. (There is no sense in forcing them to swim through any more roiled toxins than they already must.) Right now, though, the crane is still.

"Maybe they're having lunch," Blomberg says. We make to leave, but a few minutes later the crane belches awake with a snort of black smoke. The engine grumbles horribly and the great boom swivels over. The clamshell scoop that dangles from long cables is radically agape. It plunges into the river, spasms shut, and resurfaces with sticks and other detritus stubbling its clamped jaws. Dark water cascades over its rim and back into the river as the boom swivels back to the other barge, where the scoop vomits out its load with a heavy *sloosh*. The boom lurches back to the spot and the scoop plunges down again.

There are, Anderson tells me, competing schools of thought when it comes to dredges. "It's a question of precision and expense and volume," she says. The clamshell scoop is best for both volume and expense, but in its plunging, rooting around, gulping, and withdrawing it is not a precise instrument. During one of the first major cleanup projects just south of Harbor Island, a clamshell scoop dredge duly hauled out its volumes, but in its sloppiness it also broadcast

PCBs over another four acres of river bottom. Faced with this contingency of its own making, King County had to pay an additional $200,000 above the more than $10 million already spent. Such is the nature of cleanup on the Duwamish: ever expanding, ever radiating out from a malignant source or sources.

As we motor back to the waterfront I ask where all the sediments will end up. Blomberg points to the enormous gray factory near the river mouth: this is Lafarge Cement. The factory shifted away from making only cement a few years ago and has since refashioned itself as a way station for Duwamish sediments. ("They managed to save a few jobs that way," Anderson says.) When the barges are full a tug pushes them here and workers offload the mud into a containment vault. There it is treated with cement kiln dust to remove water, which lessens its weight. Once it is dry it is loaded into lined railway containers to wait for the garbage trains that will take it all away.

. . .

This is the first I have ever heard of the great Washington garbage trains. There are four of them, and at any one time two are running on a near-ceaseless circuit, collecting garbage from stops all around the state. Once a train reaches its full complement of cars it will have as many as 150 and be more than one mile long. Each car carries up to thirty-two tons of compacted trash.

At the height of a dredging operation, a single train might have seventy cars containing up to two thousand tons of mud from T-117. The train brings the mud to a rail yard on the banks of the Columbia River in Klickitat County, 250 miles southeast of Seattle. The rail yard is a few hundred feet below the bluff where I stand a week or so later. A line of semitrucks creeps into the yard like a host of dutiful and unnaturally patient ants. The train nudges forward, a truck takes a container and rumbles away, the train nudges forward, a truck takes a container and rumbles away. From my vantage the operation looks slow, but it is actually quite brisk: the train will be cleared of cars in just five hours. Two trains come through each day, one in the morning and this one in the late afternoon.

The loaded trucks begin a slow, laborious climb up a winding private road, which ends at the Roosevelt Regional Landfill. At over 2,500 acres Roosevelt is the largest private landfill in Washington. It sits atop a plateau in a natural bowl so perfectly suited, meteorologically and geologically, to holding tremendous amounts of garbage that it is like the land was begging for a giant dump. Which it got. Roosevelt now takes in more than two million tons of trash every year, some of it from as far away as Guam.

Once a truck reaches the top of the plateau it transfers its load into one of the landfill's active cells. Decomposing garbage oozes roughly five million gallons of noxious liquid each year, so the cells are doubly lined with seamless polymer sheets. The clay below the liners is all but impermeable. In the extraordinarily unlikely event that the liners leak, it would take, per the most reliable statistical models, fifteen thousand years before any liquid reached the groundwater. Rotting garbage also produces prodigious quantities of methane gas. Nearly all that gas is captured and directed through a series of pipes to a small municipal power plant on the landfill's perimeter. The plant provides 17.6 megawatts of energy, enough to power more than fifteen thousand homes. All in all the Roosevelt Regional Landfill is a miracle of modern refuse management, or so says Art Mains, the landfill's environmental manager, who is with me on the bluff.

The facts and figures are interesting, the many virtues of Roosevelt all well and good, but I want to see the mud itself.

I had imagined scenarios as I drove out here from Seattle: the poisoned sediments glowing green, emanating a foul heat, kept apart from the boring old domestic trash. Exiled to a safe corner of the landfill, no doubt. Maybe behind walls of thick concrete. Wreathed with barbed wire. Perhaps I would get to wear a hazmat suit.

Mains is bald and slightly pink, and surprisingly cheerful for a trash enthusiast. He chuckles when I voice my expectations. "No, no," he says. "It's not like that." Here in the landfill the sediments are nothing special. They are tested and permitted because they come from a Superfund site, but by the time they get to Roosevelt they have lost their menace, to say nothing of their mystique. ("We get some fish processing waste from Alaska," Mains says. "Now *that* stuff is pretty gnarly.") With their high moisture content the sediments actually serve a useful purpose. Mains explains that to keep loose trash from blowing around during the night, staff at the end of a shift will cover a mound with loose soil—including, if available, dirt from the Duwamish.

I ask if I have heard him correctly. If it is true that the sediments, the cause of so much strife and anguish back in Seattle, are just shoveled on top of garbage at the end of the day, nice as you please. "Sure," he says. "They're not that big of a deal."

We get back into Mains's SUV so he can take me to an active cell where a recent haul of Duwamish sediments lies dumped, awaiting use as soil cover. We make our way through the landfill's labyrinth of gravel roads, the vast array of active and inactive cells—garbage past, garbage present, garbage yet to come. At last we crest a hill. Before us looms a huge mound of refuse. Mains tells me it is akin to an iceberg. The trash may extend unseen up to fifteen stories deep. "We're like the garbage fairies," he says. "Out of sight, out of mind." Several bulldozers and compactors work the mound.

They drive back and forth over it, back and forth, crushing it, grinding it into the earth. They will do this for hours, days even, until all the space in the landfill is exhausted, which will not be for at least a hundred years.

Mains drives on and then pulls up on an elevated expanse of dirt. "Here you go," he says. "These are from T-117." My window purrs down and a mild odor wafts in, but it is not as strong as one might expect. (I have promised not to sue; Mains still asks that I stay inside the vehicle.) I look out at the sediments, removed as they are from their context and dumped unceremoniously in the dry electric cold of the eastern Washington winter. They are piled five or six feet high, several thousand tons of them, spread out to cover hundreds of yards. They are clumped and dark brown in color, like humus, but they do not have the richness of earth. The overpowering impression instead is one of filth: even as dirt, they are filthy and soiled.

Flocks of starlings and ravens pick through the mounds. Hundreds of gulls whirl high overhead like dust motes. I can't say exactly why, but I am subdued, even disappointed. Mains seems to sense this. "You'd be amazed by some of the stuff we find in them," he says, trying to cheer me up. "Shopping carts, sometimes. Pipes."

Shopping carts. Pipes. Yes, the sediments contain those things, and so much more. The complicated legacy of industry and growth and civic vision. The continued evolution of the greenest city in the country, or one of them anyway. The supposed end to a never-ending process. A reminder that the nature of a river is motion, whether to the sea or to these piles a few hundred miles inland.

I lean out the window and breathe in the lingering scents of the Duwamish, fill my lungs with them. The sun is high now and bakes the river away. The gulls wheel and scream, looking for a place to land.

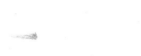

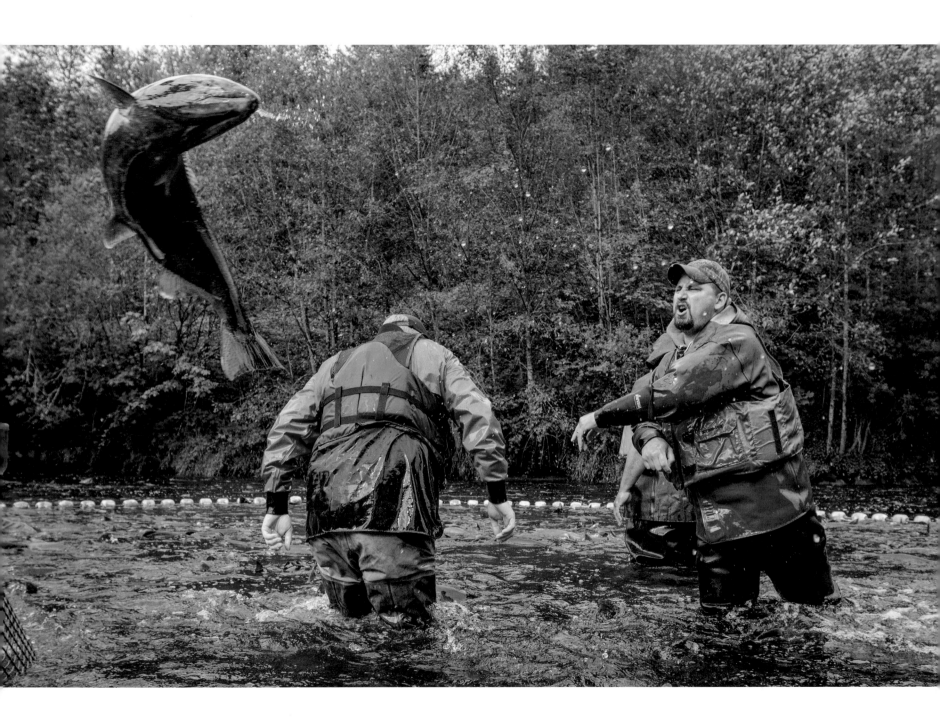

VI SOOS CREEK

Of the many signs along the Duwamish, there is one I seem to see more than most. It is in parks, on docks and piers, or almost anywhere that offers access to the river. It shows a few animals you might find here: an abridged field guide, if you will. More to the point it shows which of those animals are likely to kill you.

As an exercise in the urgent but succinct transmission of public health information, the sign is an interesting piece. It is small, about a foot tall or so, but vivid. ADVISORY is stamped across the top in bold white letters, which ensures that whatever follows will read like anything but. Reflecting the diversity of its intended audience the text appears in nine languages. The color scheme recalls that of the old terrorism watch levels. This may or may not be intentional.

Of the animals themselves there are twelve, arranged across four horizontal panels. At the bottom in threat level red are the most dangerous: mussels, clams, a crab, a perch,

Hatchery workers at Soos Creek capture and sort returning salmon

a rockfish, a flounder, a sole. These I am warned never to eat due to pollution, and I have a better idea now of what that means. At the top is a green panel. "EAT SALMON," it says. "It's the healthiest choice. 12 meals per month." Below are images of four species (coho, pink, sockeye, chum), but a lay viewer might be hard-pressed to tell them apart, I think, if they have just reeled one in. (Is this thrashing back the blue-green of a coho? The slate of a sockeye?)

Not all the salmon are so healthful. Beneath the green panel is one in caution yellow for the Chinook. Of the Chinook I should LIMIT myself to four meals per month, although the sign does not say what makes them worse than the rest. Two panels are actually devoted to the species: below the yellow is an orange one for the resident subadult Chinook, called Blackmouth, that are sometimes caught in the winter. These I should AVOID by eating no more than two per month, which strikes me as an odd interpretation of the word *avoid*.

Two small black circles intersect the green, yellow, and orange panels. Within each is the word OR in white. I take this to mean that I can eat either twelve portions of the green salmon OR four of the yellow Chinook OR two of the orange Blackmouth, but it is not expressly clear whether one yellow Chinook is worth three of the green salmon, or if one orange Blackmouth equals six green salmon or two of the yellow Chinook. Undergirding all of this, in any case, is the belief that there are enough Chinook in the river to necessitate such algebra. That might have been true years ago but it is not anymore, as they have become quite rare.

· · ·

Whatever Chinook are here belong to the Duwamish/Green River run, which itself is part of the larger Puget Sound Chinook Salmon Evolutionarily Significant Unit, or ESU. In the parlance of fisheries management, an ESU is an attempt to account for the geographical intricacies of Pacific salmon biology. Salmon are famously faithful to their natal rivers. In some species more than 95 percent of adults will return to spawn not only in the same watershed, but also in almost the exact spot of the creek or stream in which they hatched and grew. These populations, or stocks, are largely independent of one another. They have their own genetic character and ecology. A Chinook, then, is never just a Chinook. It is a Lower Skagit River fall Chinook, or a North Fork Stillaguamish summer Chinook, or a Duwamish/Green River summer/fall Chinook (hatchery).

As a management entity the Puget Sound Chinook ESU contains twenty-two such stocks, from the Elwha River on the Olympic Peninsula south to the Nisqually River, near Olympia. At least sixteen other stocks have gone extinct in the last century. Those that persist do so at about 10 percent of their historical levels, and the ESU as a whole was listed as threatened under the Endangered Species Act in 1999, joining forty-two other threatened or endangered salmon ESUs throughout the western states.

The main cause for the Puget Sound Chinook's decline, like that of other salmon, is habitat loss. Many of the estuaries critical for the survival of juvenile salmon have been filled or otherwise developed. Dams, dikes, culverts, and other obstacles prevent adults that want to breed from returning to spawn. Logging fills streams with silt, slows their flows, and raises their temperatures, which makes them less hospitable to eggs, or newly hatched alevin, or fry. Poor hatchery practices and overharvest cause further harm, as does climate change, but even with these broader circumstances the Chinook of the Duwamish bear a special burden. The river, says the ESU recovery plan, "embodies all the challenges facing Puget Sound salmon—growth pressures, shoreline alterations, combined sewer overflows and stormwater runoff, contaminated sediments, industrial development and up-river passage barriers and habitat changes due to dams, commercial forestry, and agriculture."

Biologists estimate that in the past the yearly runs of Duwamish/Green River fall Chinook could exceed forty thousand salmon. The average now is closer to ten thousand, although the actual number can vary. In 2014, for example, nearly eighteen thousand Chinook returned to spawn, and while the drop from the older peaks is obviously significant, the Duwamish/Green River Chinook is among the more successful of Puget Sound's stocks. But its seeming success is conditional. Of the 17,665 Chinook forecasted to return in 2014, 15,786 of them—close to 90 percent—came from, and would eventually return to, one place: the state salmon hatchery on Soos Creek.

· · ·

Bucket of eggs and milt

Soos Creek begins in a glacial plain close to the city of Kent. Its drainage covers about seventy square miles, and the creek joins the Green River near Auburn, thirty miles southeast of Seattle. The hatchery is less than a mile up the road from that juncture. Here the creek runs shallow and quick and clear, with a naïve frivolity. Red alders trail their branches like fingers in the water, which on this September day is alive with salmon, with Chinook, laboring against the current.

In the late summer I often visit the Hiram M. Chittenden Locks to watch the salmon swim up the fish ladders on their way to Lake Washington and beyond. Sockeye and coho are the most common species, at least when I have gone, but sometimes a Chinook will pass by. When one does it is an event. People exclaim and jostle one another, pushing their faces against the thick glass. The Chinook hangs before them with its slack jaw and lidless eye, lazing against the rush of water. Its body gleams silver and its mouth and gums are as black as oil. It is so much bigger than the other species of salmon—at least three feet long, perhaps forty pounds or more—and those smaller fish shadow it, servant to its haughty magnificence: Tyee, the king salmon, king of fish.

In Soos Creek the Chinook have a much humbler cast. They have exchanged their silver for sylvan and are a deep, black-flecked green that blends with the shadowed creek. A warm reddish hue starts near their pelvic fin and spreads to their tail, like the rippling glow of embers. They stopped eating long ago and show signs of weakness and wear. Some are heavily abraded, their noses especially, which on the males have lengthened and curled in on themselves. (All five Pacific salmon and the steelhead are members of the genus *Oncorhynchus*, which means "hooked nose.") A few have already died. Their bodies lie stiff on the banks; flies jostle about their rotted eyes. The living push past. They drift, surge forward, drift again. The creek is low, exposing their backs and tails. Water falls away, life falls away. Time is short. They feel this. One races out from behind a rock, water spraying as it flails, and I follow from the bank above as it swims around a bend up to the hatchery proper.

Built in 1901, the Soos Creek Hatchery is one of the oldest in Washington. It is so old that its first name was the White River Hatchery, back when that was the river Soos Creek met. After the White went elsewhere it became the Green River Hatchery. In 1995, its name changed to its present one, perhaps to ensure that it would no longer be subject to the caprices of the rivers.

The salmon approaches a low wooden structure that spans the creek from bank to bank. This is the first of two weirs the hatchery installs in mid-August when the Chinook start to return. The salmon pauses in front of the weir and lets the creek carry it back a few feet. Then its resolve stiffens and it jumps through a small chute into a temporary holding pond. (A second weir a few hundred feet upstream completes the pond.) The Chinook joins dozens of others in abruptly calm water. Where these fish swam with haste before, the slack pool seems to anesthetize their will. They mill about listlessly.

A small whiteboard outside a nearby building keeps a running tally of the pond's occupants. To date, 2 coho, 127 steelhead, and 131 Chinook have made it to the hatchery, and 5 of those Chinook were released upstream because they were the offspring of a natural spawning, as opposed to being hatchery-reared. The percentage is not encouraging, but as I walk toward the other weir I see that I have not given these hatchery Chinook enough credit. Some are poky, but many more cluster against the second barrier. One, a female, flings herself onto the walkway next to it. She swims furiously across the wet concrete, pushing against a low wooden wall, before giving up and letting the film of running water send her back into the pond, where she resumes her circling.

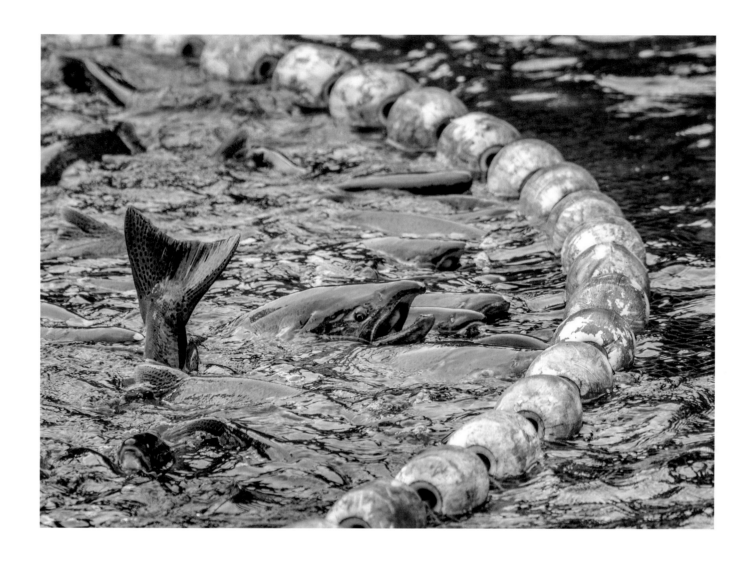

Returning hatchery salmon
encircled by net at Soos Creek

It occurs to me then that not one of these salmon has ever passed this part of Soos Creek. They hatched here and were reared here. Now that they have arrived here they have reached their beginning. According to what I have read of their biology they should be content. Yet something calls them on. They gather before the upstream weir, aching to reach a place they know in some way but have never actually seen.

Maybe this sounds familiar.

. . .

"Our past," the writer Jorge Luis Borges has said, "is our memory." I have seen on the Duwamish River that memory, and the past embedded in it, exists in many places, comes in many forms. It is a map in the cultural center of an unrecognized people, an old story told a hundred different ways, a small island, a chemical in the mud. On Soos Creek it is a salmon. But memory can be more than thought or tale, image or thing. It can also be sense, with its own physiology, etched not just in the mind but in the body, in blood or bone.

Here is how a salmon remembers where it comes from. Called the olfactory hypothesis, it was proposed in the early 1950s. Like the best hypotheses it is a series of simple statements that build in force until the strength of their elegance becomes clear. Those statements are:

1. Rivers differ in chemical composition. The rocks they rush over, the soil that rain carries to them, the trees and plants that fall into them and rot, the dust that the wind blows onto them—all these things combine to give a river its own unique flavor.

2. These differences are constant over time. There may be small changes from year to year, but a river's essential nature is fixed.

3. A salmon can learn the chemical characteristics of its natal river. This learning occurs when the salmon develops from a parr to a smolt, which is the most sensitive period of its early life. The scent of the river shapes the epithelial tissue in its nares, or nostrils, and the olfactory bulbs in its brain, permanently molding them.

4. Salmon are attracted to those learned odors. "The sensory cells themselves," one biologist has written, "have a form of memory."

Once they leave the estuary and enter the Pacific Ocean, most Chinook head north, staying near the coast until they reach southern Canada. From there some strike out for the open ocean. They mingle with other stocks and other species, forming large groups called shoals. They feed on small fish and crustaceans. They grow large. Then, one to five years after they left the river, their bodies signal that it is time to go back.

Migrating salmon rely at first in part on the Earth's magnetic field, which they use as a directional cue. Other proposed mechanisms, such as sea surface temperature, the position of the sun, or patterns of polarized light, are likely important. Some species travel quick and straight; chum, pink, or sockeye might swim more than thirty miles a day, more or less directly. Chinook and coho swim just as quickly, but they might wander a little more, taking their time to feed along the way.

It is when salmon first reach freshwater that they start to respond to the scents they imprinted on as smolts. They can detect the most minute concentrations of certain chemicals and are so sensitive to odors that they will stop swimming if a person so much as washes their hands far upstream. Movement for them happens via a series of forward-and-back

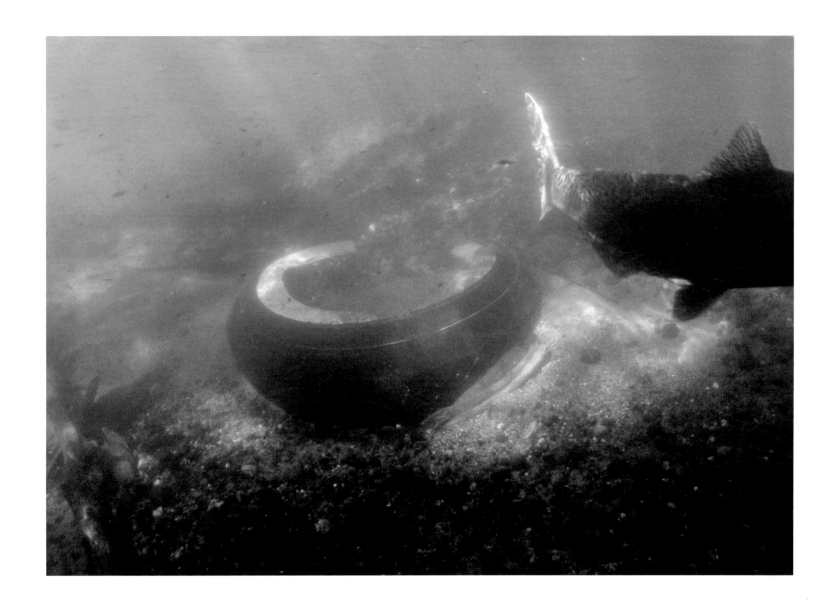

Salmon traveling upriver near Auburn

switches as they test different waters. One approaches a river and swims a short distance up it. Does it detect the old familiar smells? If yes, it continues; if not, it returns to the most recent fork and tries another way.

Scientists now believe that some salmon's map is a series of odors remembered in sequence. With that in mind, I wonder what the waypoint of the Duwamish River must smell like to a Chinook as it finds its way back to its natal stream scent by scent. Swimming from the Pacific into Puget Sound, it has passed through dirtier and dirtier water. Then it reaches the Duwamish: the dirtiest of all.

A lament I sometimes hear is that the river has changed so much from the time salmon first swam through it that they do not recognize it. That might be true for Salmon, but not for these salmon. They grew in this river, learned it. It is what they know and what they seek. For these Chinook the Duwamish's pollution must come as a most welcome and reliable sign of how close they are to home.

· · ·

A few days later I return to Soos Creek to watch a spawning. The level of the holding pond is lower by a foot and the water is thick with salmon. According to the whiteboard, there are well over six hundred. They bunch at the upstream weir with a restless, seething energy.

It is raining hard and the hatchery staff are huddled under a shelter next to the holding pond. To satisfy some legal provision they have strung a piece of string across the path, from a door handle out to a traffic cone. A wrinkled paper sign dangles from the string: "Do Not Cross." I am happy to obey, but the way everyone looks at me standing out in the downpour I wonder if this is the first time they have ever needed the barrier.

To start the spawning four biologists heft a large net and wade across the pond, threading the net between the weir and the salmon. When they reach the far bank they walk downstream toward the first weir before turning to cross the creek again. From the near bank they bring the net back to the start, closing the loop. The salmon realize what is happening when the biologists have them a little more than three-quarters encircled. They froth the creek in their panic.

Three biologists now walk among the confined salmon. They trail their hands over their backs, caressing them, but the fish twist away. A woman reaches down and grabs one, a large male, hefting it to the shelter, where a man sits on a stool and holds a small club. He gently but firmly lays the salmon across his knees and clubs it on the head with a quick, compact stroke: *thunk*. The fish shudders as it absorbs the blow meant to crush its skull. The man lets its body slide to the ground, and there is the *slapslapslap* of renewed flopping. The blow has not killed the salmon outright. It has been dying for weeks and was well used to the feel of its life departing. It can wait a little longer. A few moments later it stills, and dies.

Another biologist roots among the dead fish and selects a large female. He holds it over a white plastic bucket. Using a box cutter he slits its body from gill to tail in a smooth motion: *schnick*. Eggs spill out into the bucket. The biologist paws through to scrape out any that remain and tosses the female's body to the side. He next reaches for the newly dead male, hoists it, and angles its belly over the bucket. He palpates it, squeezes it. A thin string of white milt squirts into the bucket. The biologist tosses the male aside next to its mate. He swirls the bucket to mix the eggs and milt, and fertilization is complete.

He repeats the ritual with another pair of salmon and then another: *thunk, schnick*, spill, squeeze, swirl. The buckets

accrue: black ones, white ones, orange ones now and again. If I squint they might all be redds.

. . .

A river without fish is no river at all, and at heart the restoration of the Duwamish River is for these salmon and everything they symbolize. It is a simple braid. If the restoration is to succeed, there must be salmon. If the salmon are to succeed, there must be restoration. Even though it is twenty miles away, the hatchery at Soos Creek is as central to this goal as anything else: it is the source of almost all the salmon that will rest in the river's new side channels or lurk in the shadows of logs held in place with rebar and chains.

But a hatchery fish is an awkward ecological savior. From the late nineteenth through the early twentieth centuries the aim of salmon management in the Pacific Northwest was simply to increase the number of fish. Hatcheries were a boon: a means first of supplementing stocks that had declined due to overfishing and later of mitigating the impacts the broader transformation of watersheds was having on already beleaguered fish. In rivers technologically altered—by dams, by development, by industry—hatcheries were a technological remedy. The fish they produced were not farm animals so much as they were factory goods.

Then, in the 1970s, biologists began to examine more closely the host of successes hatcheries had claimed for themselves. (Before, most programs operated without much oversight.) They criticized what had become a standard practice: rearing young salmon gathered from watersheds all over the region and loosing smolts into rivers without a care for where they had come from or the conditions to which they might be best suited. As the evolutionary and ecological implications of the tight couplings between a fish and a place became clearer, management goals likewise shifted from augmentation alone

to the present, uneasy balance between augmentation in the absolute and conservation of endangered wild stocks in their purer genetic states. It was no longer enough that a hatchery might release millions more fish than a river could produce on its own. The question was whether the hatcheries were releasing the right fish. As often as possible, the right fish were to be wild fish.

Closer study had also shown the extent to which hatchery fish were distinct from (and thus inferior to) their wild kin. Hatcheries freed their wards from the strictures of natural selection while shaping them to the quirks of artificial, or human, selection. This led to a rise in undesirable traits. Reared on fatty pellets cast among great crowds in tight spaces, hatchery fish were larger and more aggressive. Sometimes they displaced native congeners from the streams they were freed into; sometimes they simply ate their wild relatives. Outbreaks of disease were common in the ponds, and in their new rivers transplanted hatchery smolts were sometimes susceptible to parasites to which wild fish had developed an immunity. Behaviorally, hatchery salmon were less wary. They came when food was sprinkled in the water, and they carried that expectation with them into the wild.

Hatchery salmon would come to be dark, unnatural creatures within the complex mythologies of wild salmon. The latter's thousand-mile migrations and hunger for return were already well known and revered, but biologists were learning more about the degree to which salmon left to as natural a state as possible were important nexuses throughout the wider wilderness. They stitched the disparate into a whole: streams, rivers, the mountains, the ocean. Nutrients from a salmon's body nourished lands hundreds of miles from where it had actually died. Hatcheries threatened to undo all the careful craft of evolution, and in an insultingly short time. That such an indomitable spirit could have its unique-

ness shorn away until all that was left was a bland, domesticated, foul, and sickly bovine of a fish was a deeply horrifying prospect.

Maybe this also sounds familiar.

. . .

The rain beats down and I retreat to a nearby doorway, where the pummeling on my own head, at least, lessens. I have read that for all the concerns about hatcheries, the Soos Creek facility is one of the more benign throughout Puget Sound. By relying on salmon that return of their own accord and not rearing eggs from other stocks, it has done a better job of preserving the genetic lineage of the Duwamish/Green River Chinook fall run. Its success has also had a curious consequence. The Chinook stocks of the Puyallup and Nisqually Rivers have, over time, become more similar genetically to the Duwamish/Green River stock, most likely due to the straying of hatchery fish. The memory of the Duwamish of old thus spreads to other rivers in the bodies of its most forthright ambassadors, the Chinook.

The biologists are taking a quick smoke break. They huddle under the shelter. One of them comes over and asks if I want to see where all the eggs they are harvesting will be incubated. (After more than two hours in the rain I have apparently gone from being a suspicious figure to a ridiculous one to a pitiful one, and so have earned this small measure of kindness.)

The biologist introduces himself as Joe and leads me inside the main building. I see several rows of long, low concrete troughs. The troughs are full of wire baskets, each submerged in cycling water. When the eggs first come in, Joe says, they are hardened for about an hour in a solution of iodophor before being transferred to a basket. Each basket holds up to twenty-five thousand eggs. Formalin added to the water prevents infection, while periodic flushing cleanses the eggs of sand and other detritus. When they hatch after a few weeks, the new salmon will go to the long, narrow raceways outside and eventually to one of the larger concrete ponds, where they will grow until it is time to send them out to the creek and on to the Duwamish as smolts.

I do some calculations: if each basket holds twenty-five thousand eggs, and each row has four baskets, and one full section has six rows, and two sections have their full complement, then there are 1.2 million eggs right now, give or take. This strikes me as a lot, but it is still less than one-third of the more than 4 million Chinook eggs the hatchery hopes to collect this year, with a final goal of releasing 3.2 million smolts into the creek this coming May. (They will also release 600,000 coho smolts.) It seems an impossible number, but less than 0.1 percent of them will survive to be clubbed on the head in the pond a few years from now.

Joe tells me that I can stick around if I want, and then he leaves. Soon I hear him calling out to his colleagues against the rolling boil of desperate fish. Out a window I can see a big white semi from Coastal Harvest, a regional food bank. Once this round of spawning is done the truck will take the dead Chinook to centers around the state. Much like their wilder counterparts, the bodies of these salmon will provide nourishment many miles from here, throughout the modern food web of which the Duwamish River will always be a part. It seems a fitting end for them, these unreal fish from an unreal river.

I once was talking to a state biologist about the predicament of Puget Sound's salmon, and that of the Duwamish/Green River fall Chinook in particular. He considered all the money spent trying to sustain this run a waste. "We made our choice," he said. Other runs had a better chance of recovering, they could use the help, and so we should be will-

ing to let these fish go. That would be the more courageous choice. Certainly the more honest one.

In the hatchery among all these eggs, all this effort, I wonder whether he is right. Battered after more than a century of choices, these salmon could not endure without our massive intervention. Does that mean we should forsake them? It is a question we could just as easily ask of their river, and in the cool calculus of a cost-benefit analysis perhaps the answer is yes. But the Duwamish River has always been a place to test the surprising range of the possible. Settlers looked at acres of mud flats and forest and saw a city. City engineers looked at a floodplain and saw a waterway. Businesspeople looked at a waterway and saw a waste management system. Now, we look at a Superfund site and see a healthy river filled with fish that are safe to eat. All those earlier visions came to pass. Why should this latest not as well?

So we keep the salmon and try to make the river worthy of them. I peer into one of the baskets with its tens of thousands of eggs. In a few months fish from these eggs will taste that river for the first time. The flavors of the Duwamish will become their being. I want to touch them, to run my fingers through them, but I don't. They have already been interfered with enough and they have not even hatched yet. Let me spare them my good intentions. I study instead one of the eggs that sits at the top of the pile, just near the surface of the water. It is the size of a pea, perfectly round, and a mild orangey peach in color. It is so fresh and new that there is no visible hint of the salmon assembling itself within. Only the promise. A difficult promise, an ambiguous one, and maybe a terrible one, but still: the promise of a life.

PHOTOGRAPHS

Tom Reese

South Park shoreline, about eighty
river miles from the headwaters

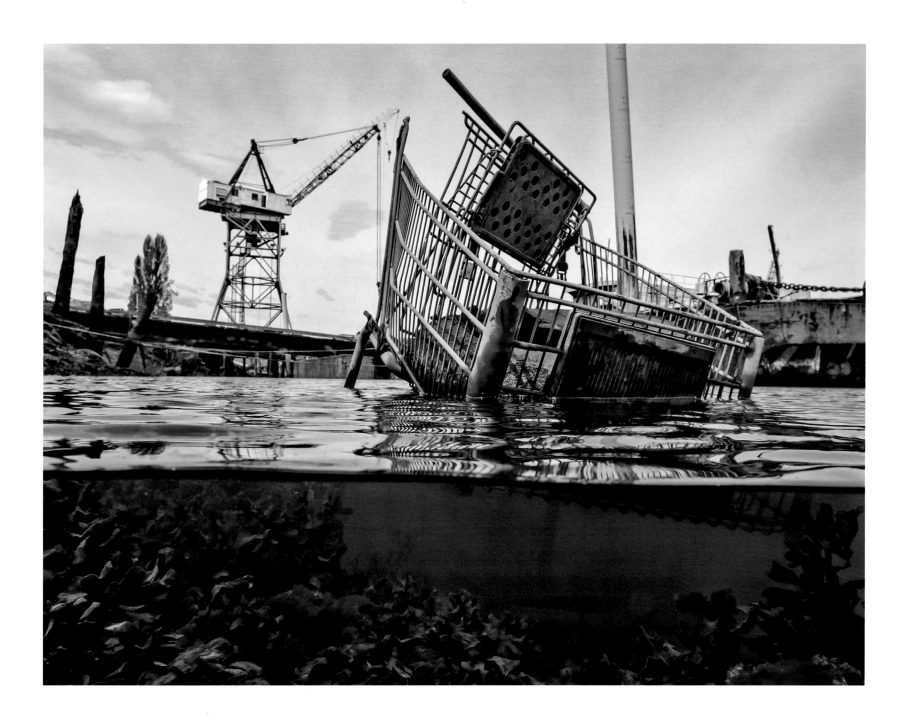

Juvenile hatchery salmon released
into Duwamish River system

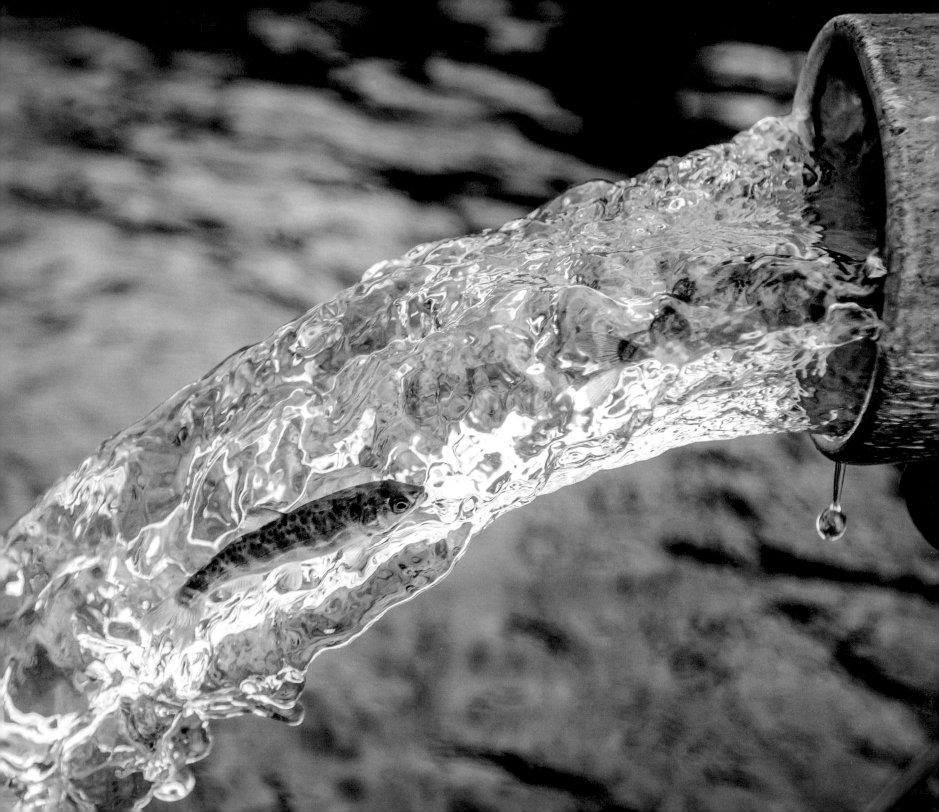

Headwaters of the Green and
Duwamish River system on the
west slope of the Cascades

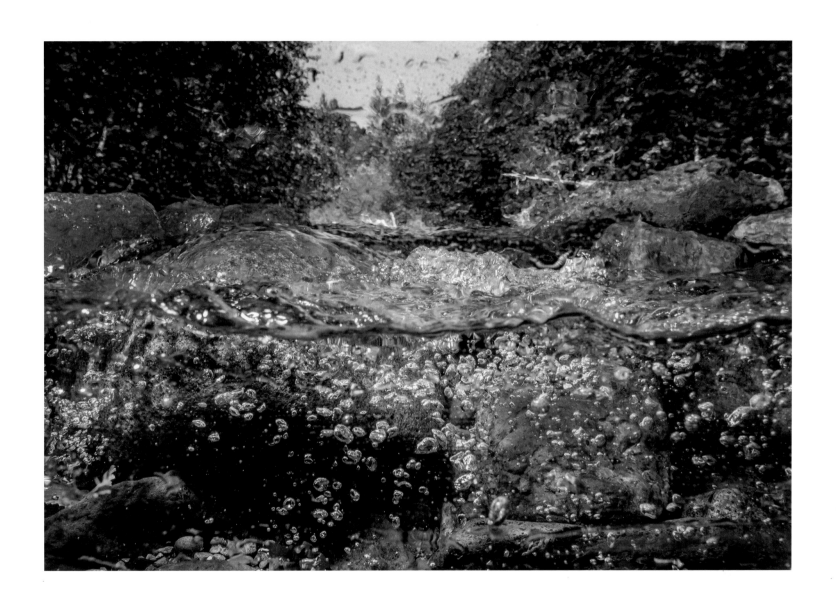

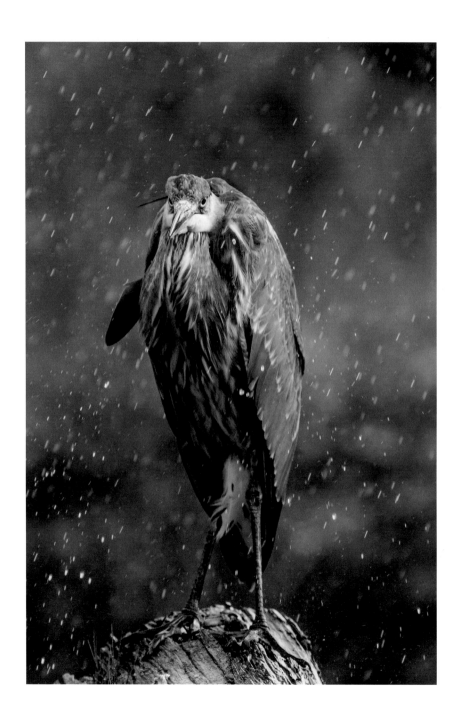

Great blue heron in hailstorm
in Terminal 105 Park

Water flowing into the Duwamish carries
contaminants from multiple sources

Sunrise over Boeing Plant 2,
Jorgensen Forge, and Terminal 117

Harbor seal, pipe draining
near Boeing Field

Barrel ride, Tukwila
Community Center

Drum reconditioning, South Park

Salmon swims toward Soos Creek Hatchery

EPA diver samples bottom
sediments near Harbor Island

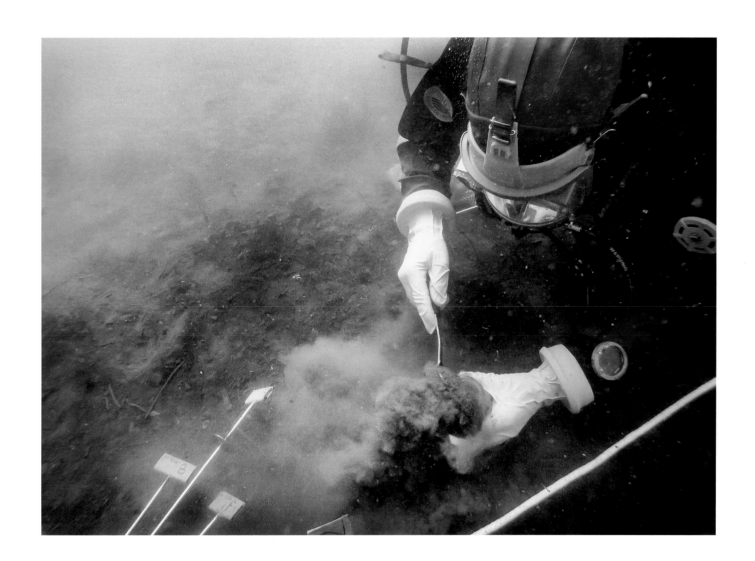

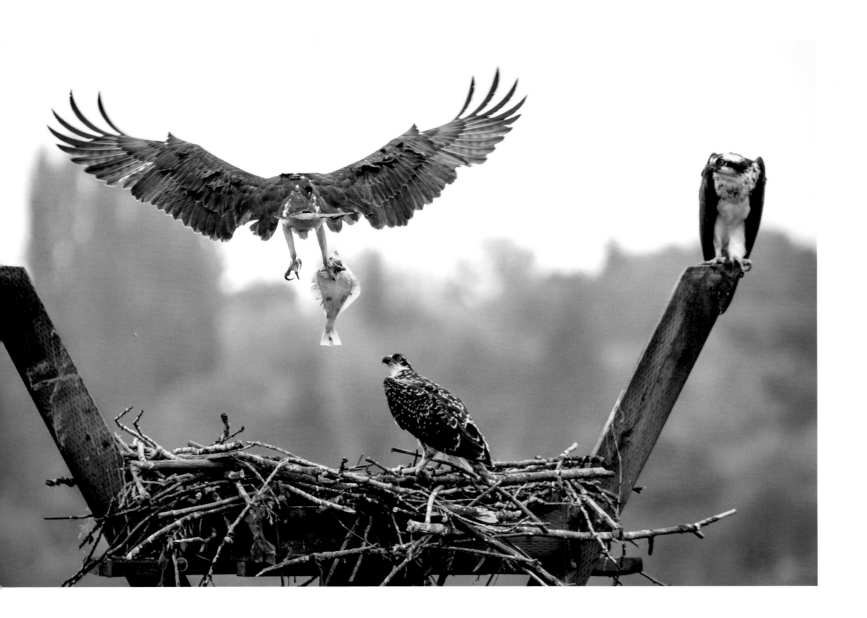

Ospreys migrate seasonally from
Central and South America to breed
along the Duwamish

Restored riverside beach in South Park

Sign on truck delivering
scrap metal

Sediments dredged from Plant 2
cleanup site await removal by barge

Net fisherman exercises treaty rights

Volunteers at organized cleanup
remove trash from river

Duwamish River Cleanup Coalition worker
removes invasive plants before replanting
with native species

Volunteers work to reclaim beach
at Herring's House Park

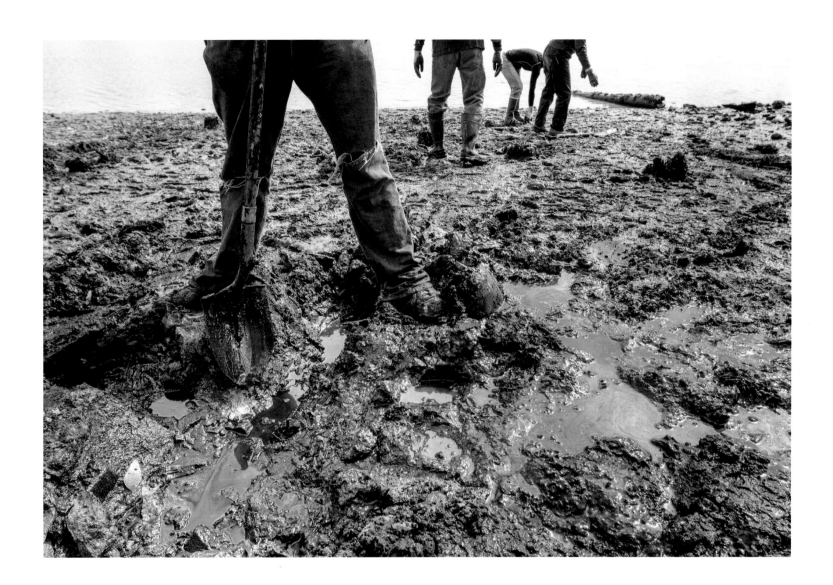

Truck on sunken barge, with barnacles
accumulated over many years, before
its eventual removal

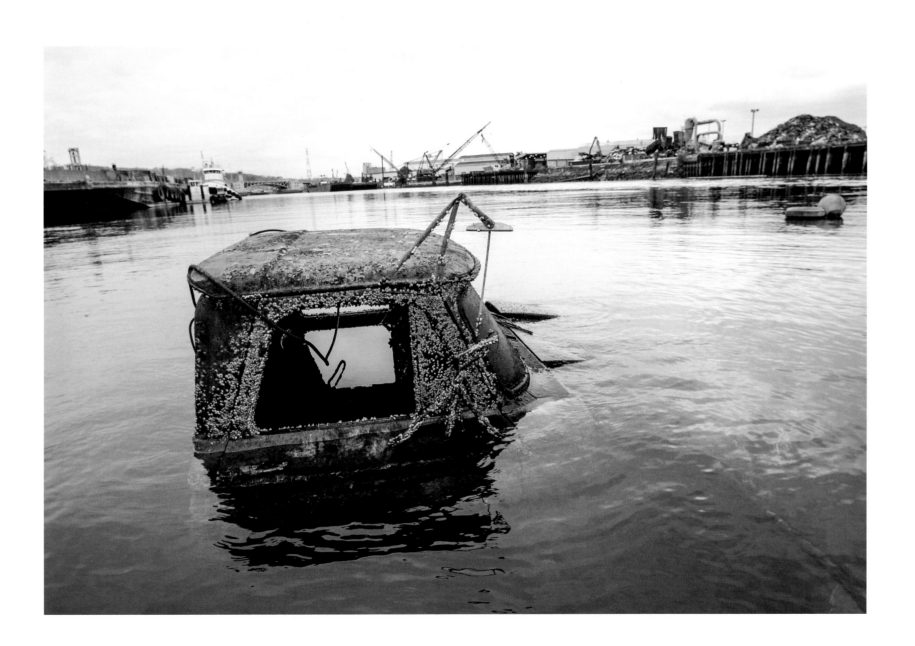

Scrap from many places is processed
at Seattle Iron & Metals in Georgetown

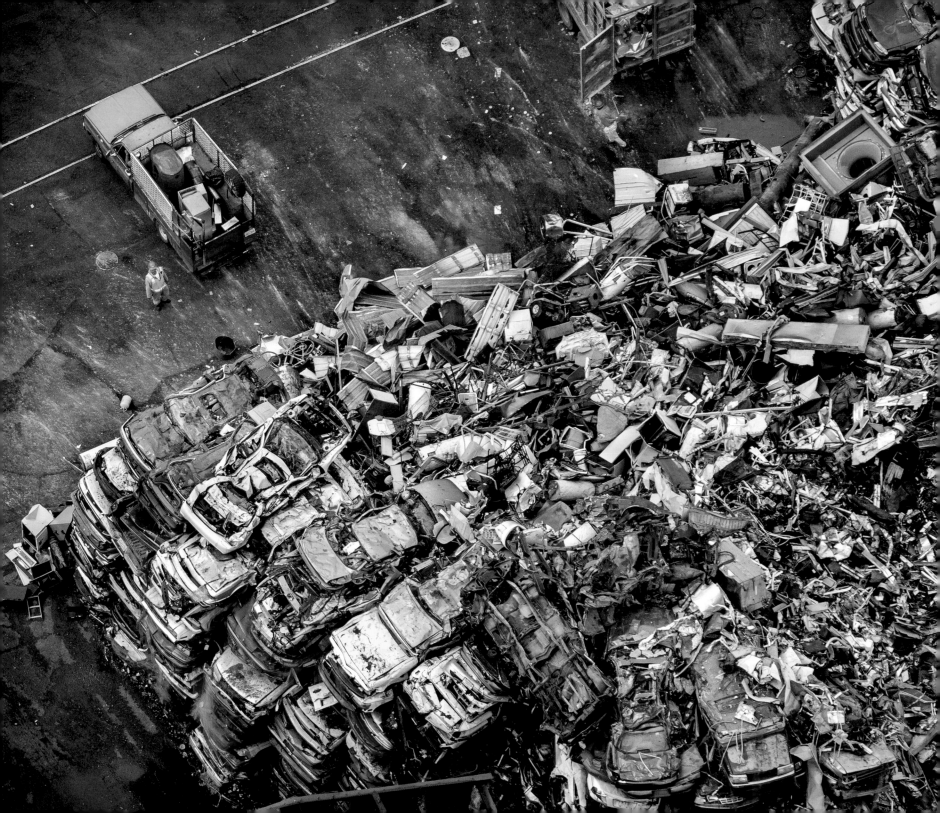

Early Action dredging near Boeing Plant 2

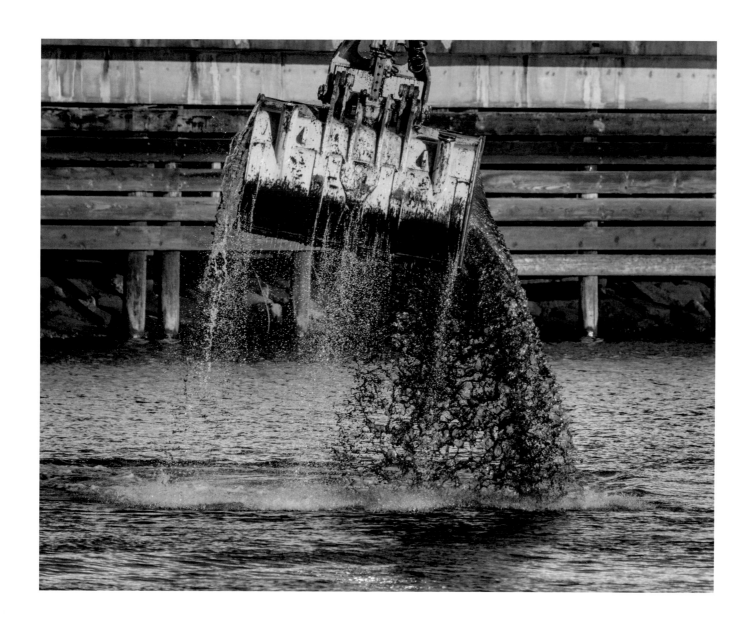

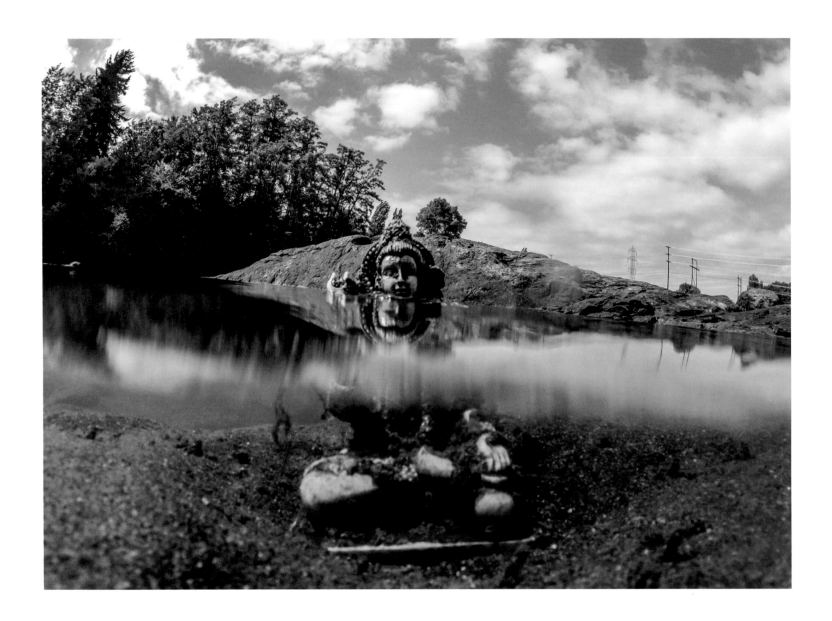

Statuette submerged by tide, North Wind's Weir

Cat, Tukwila

Lucha libre wrestler, South Park

Neighborhood families at EPA cleanup
proposal meeting, Georgetown

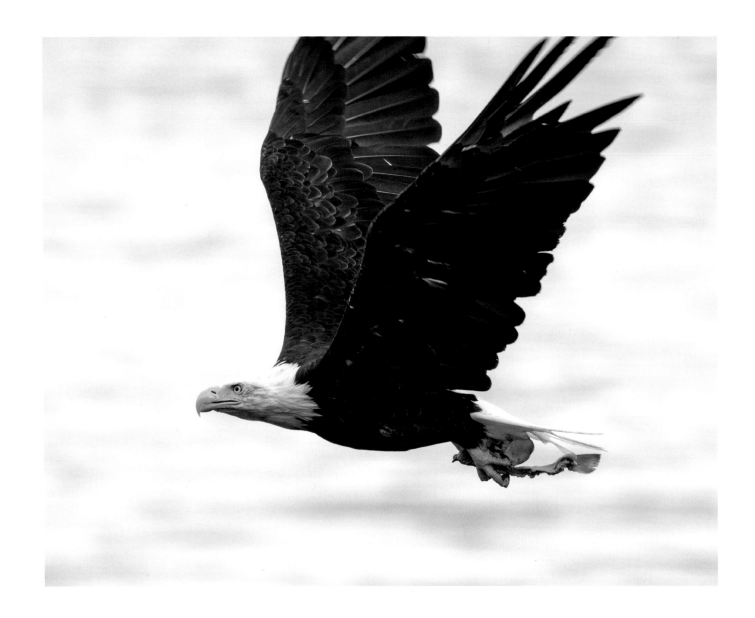

Eagle carries fish to nest along the Duwamish

Mail sorting facility near North Wind's Weir

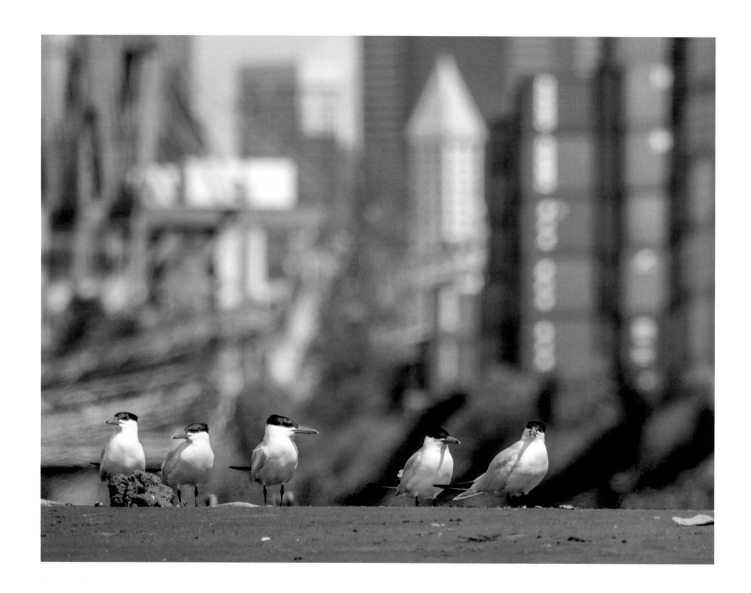

Caspian terns, Kellogg Island

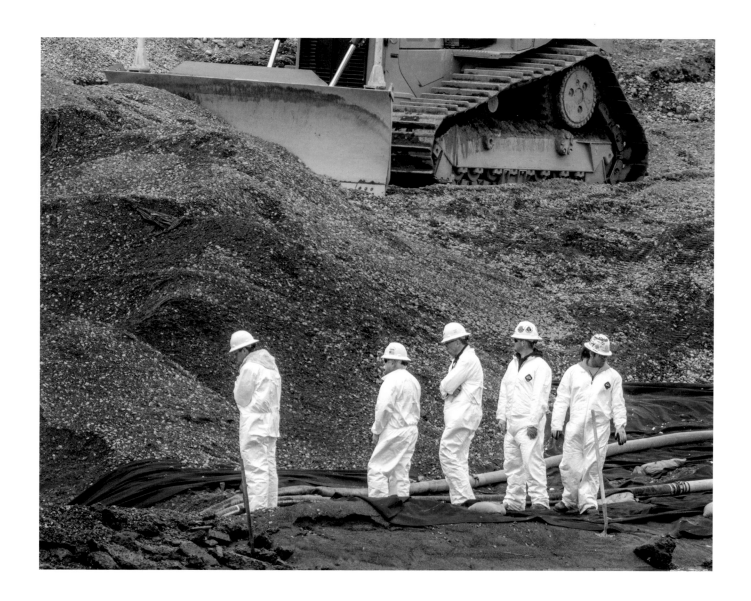

Workers cap sediments with gravel
for Plant 2 waterfront rehabilitation

Swallows on security fence around
Boeing property, Tukwila

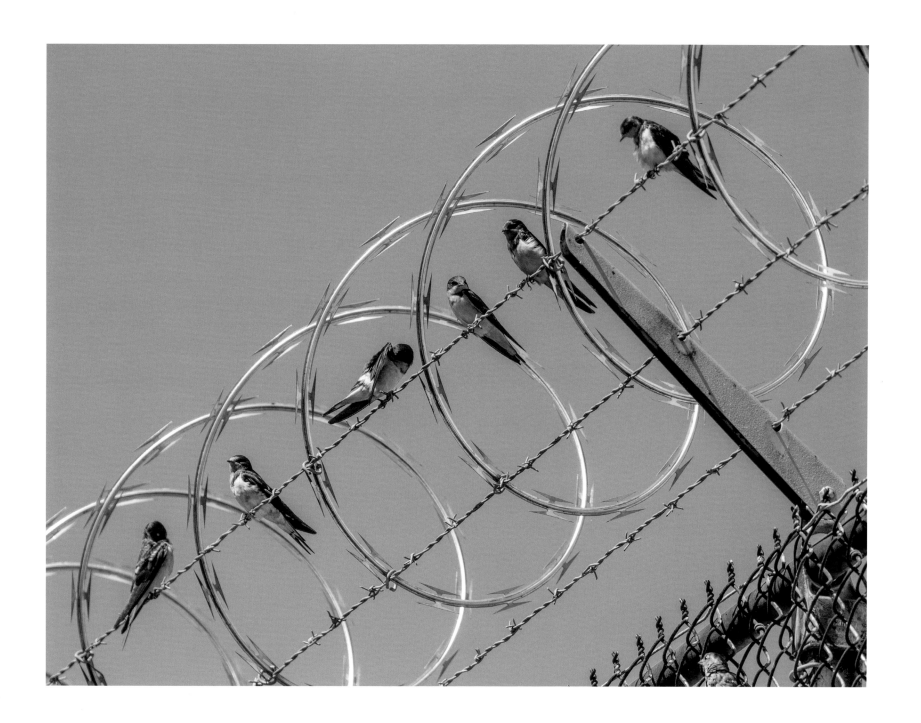

Barges bring scrap long distances
to be recycled along the Duwamish

Lafarge Cement plant,
West Seattle shoreline

Northern flicker hatchling along Green River Trail

Gourd hung to replace lost nesting habitat

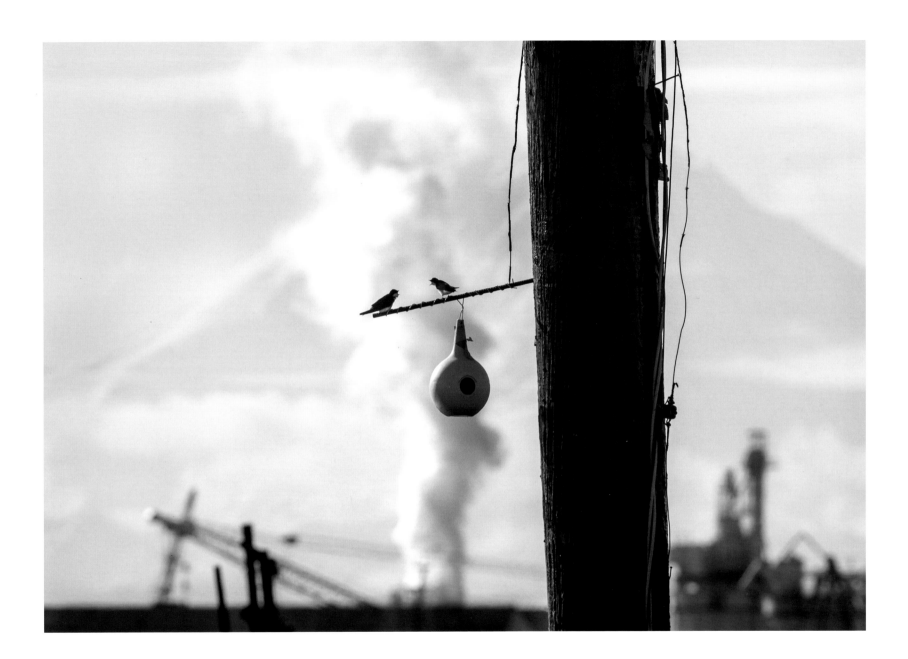

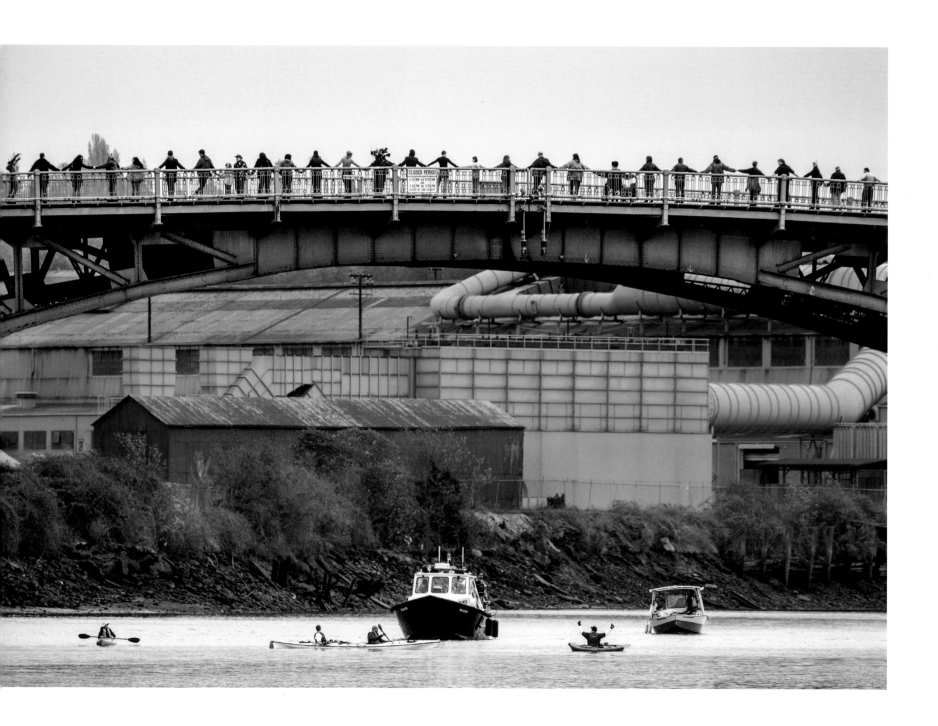

Neighborhood advocates hold hands
across old South Park Bridge

Celebration at opening
of new South Park Bridge

Pile of recycled concrete,
Skyway neighborhood

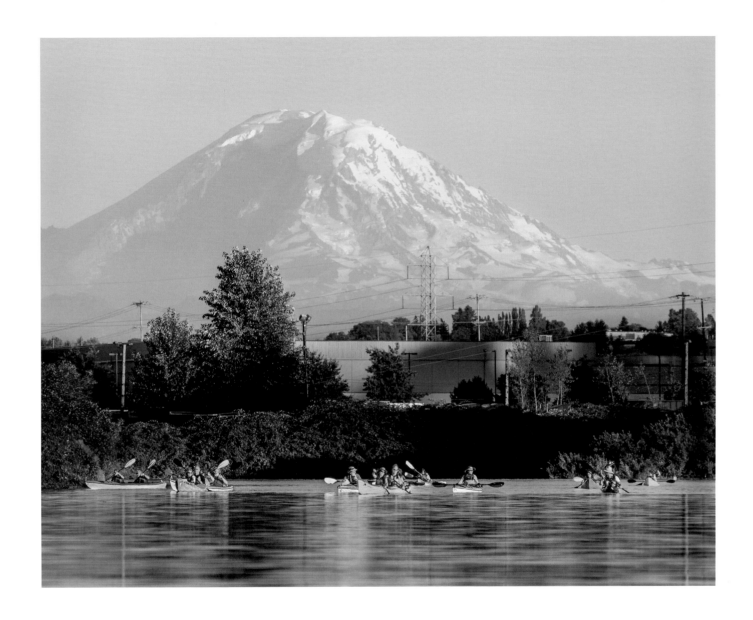

Paddlers in turning basin at southern
end of Duwamish Waterway

Harbor seal pup hauled out to rest,
West Seattle

Healing ceremony for the river,
South Park

Curiosity, Georgetown river bank

One-day collection
by cleanup volunteers

Osprey nest from locally sourced
materials, Hamm Creek

Traditional Duwamish welcome
offered to canoe team landing
at Herring's House Park

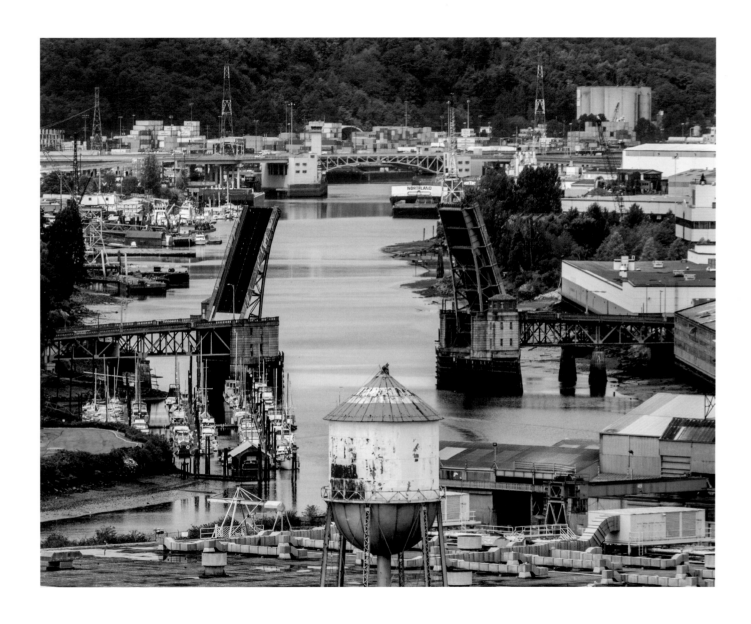

River landscape at South Park
and Georgetown, including old
South Park Bridge

River otter, South Park

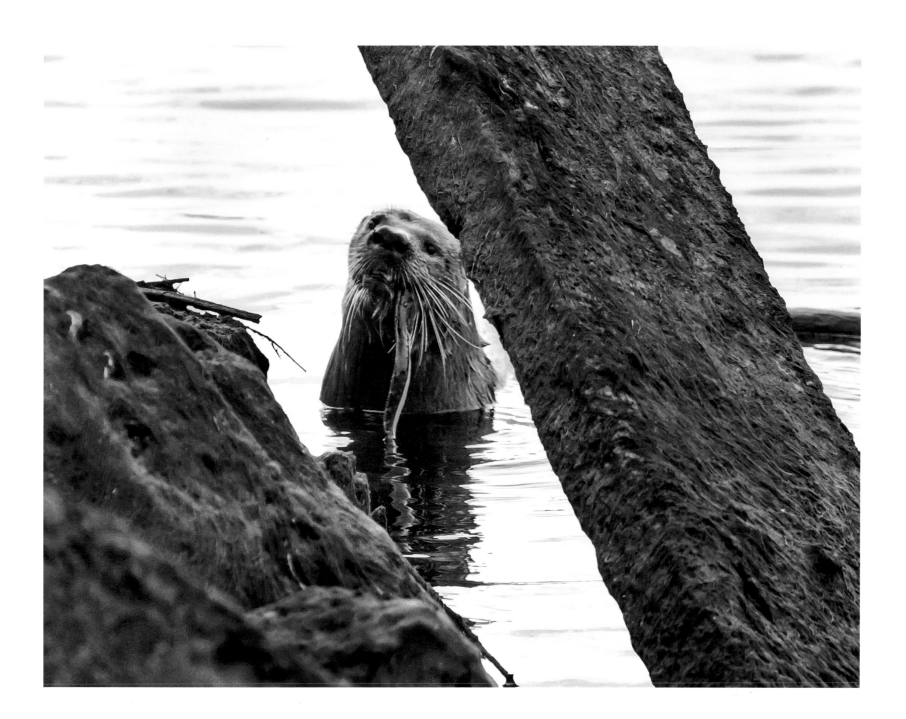

Parade, Chief Seattle Days, Suquamish

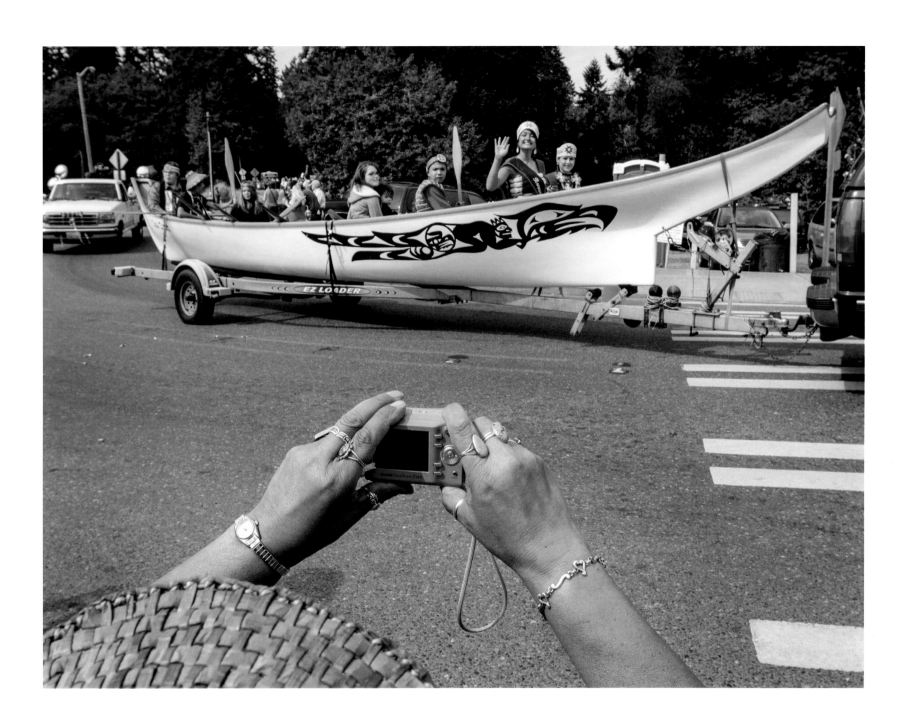

Storm Wind, detail from *Northwind
Fishing Weir Project* by artist Susan
Point, along Green River Trail

Drummer at powwow
in Discovery Park

Student volunteers restore habitat
in Herring's House Park

Marina resident on mission
to remove river trash

Stone carving by Roger Fernandes,
Green River Trail

Boeing Employees' Credit Union,
Tukwila shoreline

Barge under repair, Georgetown

Ash Grove Cement plant,
pipe remnant at T-105 Park

Temporary camp in
Herring's House Park

Runoff from West Marginal Way South enters river

Macklemore lends image to cleanup campaign

Urban fisherman near North Wind's Weir

Sea lions, where the Duwamish
flows into Elliott Bay

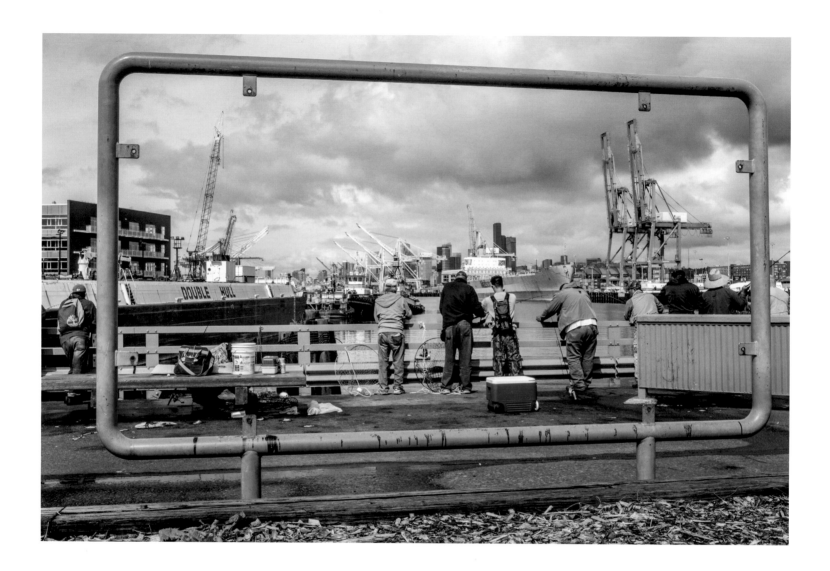

Fishermen on bridge over East Waterway,
adjacent to Harbor Island

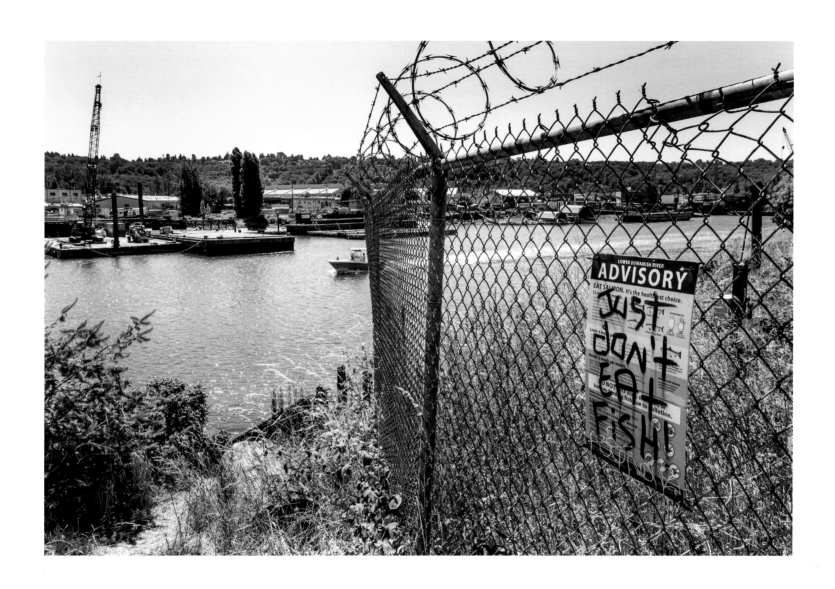

Annotated seafood consumption
advisory, Georgetown

Bouquet left on bridge beam near
North Wind's Weir

Cleanup volunteers and heron
near stormwater drain

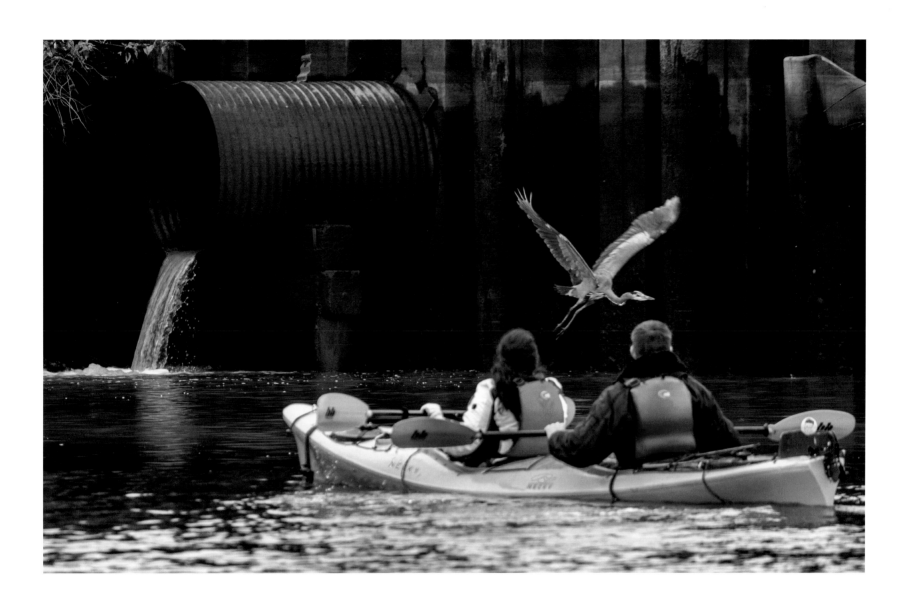

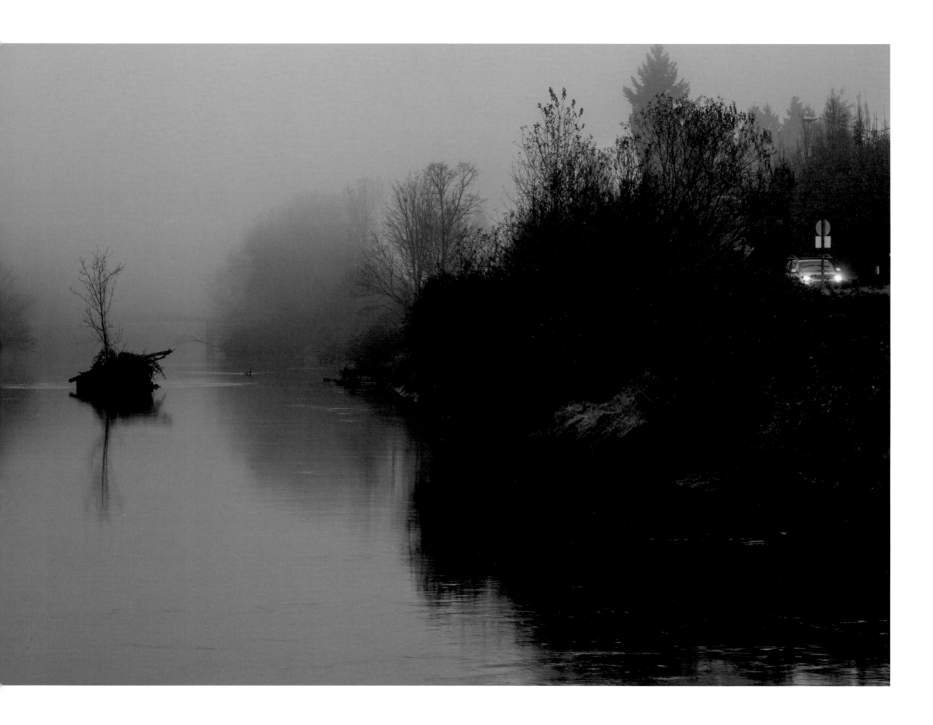

CODA

Tom Reese

All land, no matter what has happened to it, has
over it a grace, an absolutely persistent beauty.

—ROBERT ADAMS

There are no photographs of the Duwamish River at its most sublime. That was too long ago.

We can picture its beautiful abundance by listening to the stories written in rocks, animals, plants, air, and water told in scientific narrative, and by listening to the music in stories told person to person from deep time.

As modern people, though, we believe what we see.

I have been acquainted with this damaged place for more than twenty years, and what I see compels me to photograph with both affection and desperation. There is abundant loss and disconnection to be found; yet every time I settle into a kayak or wading boots and push off and away from the city's hard ground, into the flow of the Duwamish River, it feels like belonging.

Revelations from this landscape can seem both true and implausible. *That just can't be right.*

Can't be right—the mind struggles to make sense of ambiguities and contra-dictions to be found everywhere. A Superfund site is beautiful at sunrise. Harbor seals with puppy eyes eat a stew of hidden dangers.

Can't be right—the spirit stings from bearing witness to injustices, also to be found everywhere. A waterfront park features crumbling concrete, suspicious mud, clanging machinery. Fellow human beings are disconnected and disenfranchised in their own community.

To accept the evidence of injurious human choices that have been made during the last hundred years is to wonder what those people were thinking and whether we are much different. But to accept the evidence that wildlife and plants and people are at home on the river these days is to allow ourselves wonderment.

The Duwamish is still a liminal place, never settling for long. It has been transforming since volcanoes and glaciers and water flowed into the land. In its present state, it embodies the tensions between man-made and natural,

Remains of 1903 Riverton
Draw Bridge, Allentown

between competing visions for the future, between dying and living.

Though not everyone concurs, I find hope in the possibility that we can also transform, that by looking deeper instead of looking away we can continue evolving in ways that help the river heal and reach its next full potential, whatever that might be. I am grateful to have been shown reasons for this optimism: caring work has already improved habitat and health; attitudes about how we make use of the place in which we live seem to be progressing, within individual people and at least in pronouncements of some influential institutions; large-scale cleanup is beginning; and the river seems to have a life force that people can sense, resilient and defiant.

The Duwamish also informs our subconscious desire for connection and our intensifying undercurrent of worry. It can transport us to places within and beyond our own lives, reminding us what is precious, asking for our devotion.

We have put ourselves in charge of Earth and have choices to make. What are our obligations and opportunities? As we struggle to find our place as humans in a fragile world, my wish is that we will renew a relationship we recognize deep within from long ago: We don't really want to separate ourselves from other parts of the natural world, even the neglected ones. We want to embrace all of it. We want it to embrace us.

Reclaiming the Duwamish River is about reclaiming ourselves. There is a lot left to save.

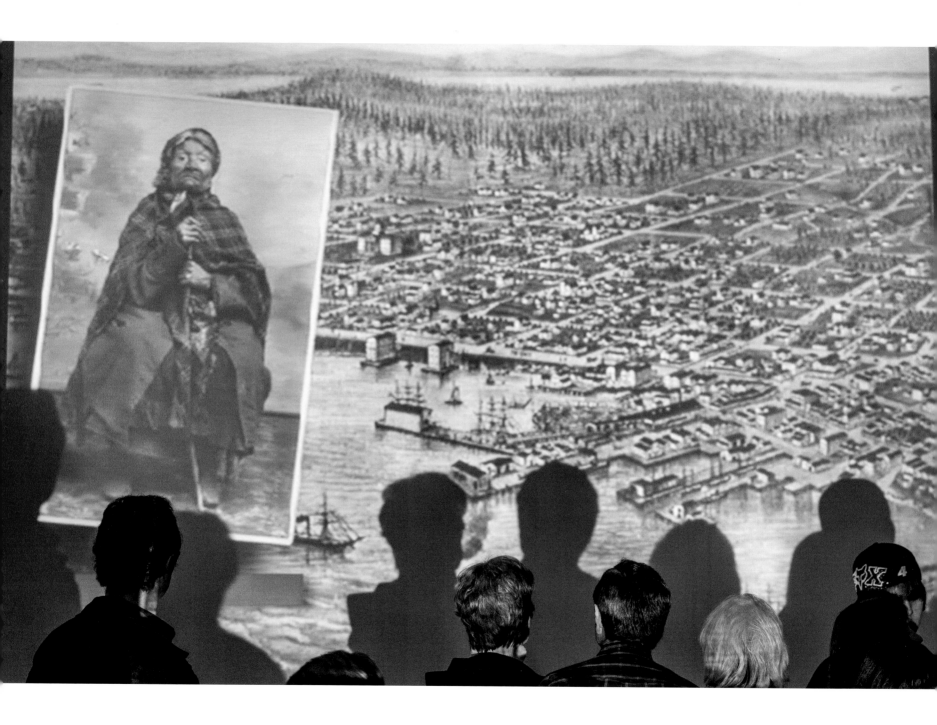

AFTERWORD

A RIVER FOR ALL

I have worked on the Duwamish River for over thirty-five years, doing everything from creek restorations, to river patrols, to sitting on committees that help guide the river's recovery. Why? I *am* Duwamish. I come from a people who have been here for ten thousand years or more. I have been taught from a child to be very proud of that, and I am.

My work for the river began when I listened to the late John Beal's appeal to the Duwamish Tribal Council to support his work on the Hamm Creek tributary and the Duwamish River itself. I was new to the council then, and I was struck that restoring the river was an important thing for my tribe, so I asked for the council's approval to work with John. I didn't know it at the time, but that request would change my life.

The river was in bad shape. It was firmly entrenched in an administrative no-man's-land. Spills were intentional and frequent. The state of the river at that time paralleled that of the tribe. Without federal recognition

and operating out of a small office in Burien, the tribe was not able to help its members. We were struggling, just as the river was. But also just like the river, we were and are both *still here*.

I was already familiar with the river's past, its stories and myths, but the more I worked on the river the more I realized that the river itself was alive. That might sound strange to some people, but this is a special place. Through all the industrial growth and changes to the river, it continues to flow, not just with water, but also with the souls of the people who have loved it. People like John Beal, and my own ancestors. They all had a love for the river and its old soul.

As time passed and I became more deeply involved with the river, the work raised bigger questions. What is environmental justice? What does it mean? What is community? We—the city, the county, the port, all of us—have a real opportunity here to do more for the river and this place. And the river is starting to get better. People from the surround-

Documentary *Princess Angeline* screens at Duwamish Longhouse and Cultural Center

ing communities have come forward to join in the work that needs to be done. Just like a person recovering from an illness, the river is becoming healthier. It provided for so many people for so long, and it can do so again. It is now a place where people can come to work, to play, to fish, and to worship in their own ways.

We need to always remember that the wealth of Seattle was created on the backs of the Duwamish River and the Duwamish people. Both the people and the river are still here and getting stronger, but we cannot rest yet. More of us need to understand how we can help. And as you help the river, as you discover its magic, it will help you. Tom Reese's photographs are indeed magical, but they only scrape the surface of this place called Duwamish. The river has changed his life, as it has changed mine, and as I have seen it change the lives of the many people who have committed themselves to its healing and restoration.

I want to say thank you, from a person who has talked to the river and knows that it answers. A *River for All* means that as you help heal our river, it will help heal you. Anyone, from anywhere.

Come to Seattle's river. See and hear my cousins, aunties, uncles, grandparents, and ancestors—River Otter, Heron, Beaver, Osprey, and Eagle. Celebrate their return. Welcome the salmon back. They are from this place, just as I am. You will discover that the Duwamish River is a very strong soul.

JAMES RASMUSSEN
Duwamish Tribal member
Coordinator/Director
Duwamish River Cleanup Coalition

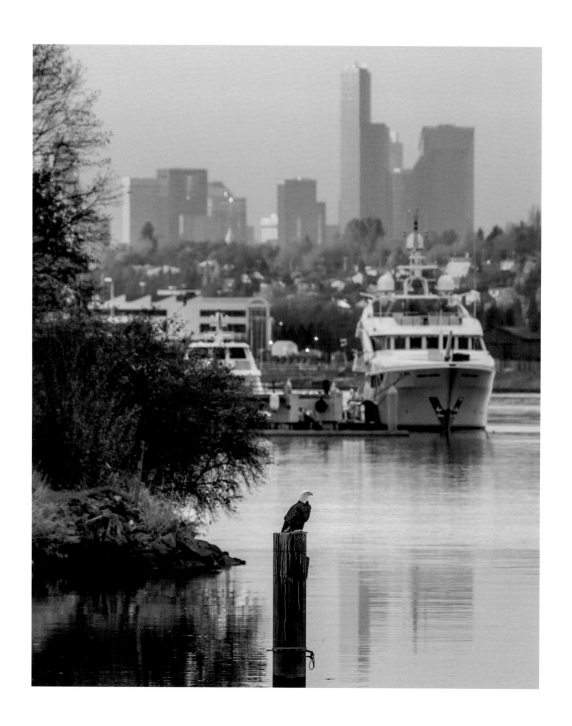

ACKNOWLEDGMENTS

TOM REESE

Richard Hugo said, "Our subjects choose us, I suppose, if we let them. Certainly, our landscapes do. They must."

Deep thanks to the Duwamish River: may you be honored by this telling of your story, and may you continue to flow powerfully through the hearts of those who know you well.

To all the human beings whose gifts and kindnesses made this work possible: I will never be able to say thank you adequately; please know that I am very grateful.

To those who have been hard at work in this landscape for many years already, caring and reclaiming: may you find your passions reflected in these pages, and may your footsteps and paddle strokes lead the way for many more.

To my son, Evan Reese, enthusiastic explorer and companion of the highest order: my deepest thanks. You inspire the most meaningful aspects of this work.

Warm thanks to:

Eric Wagner, master of observation, idea, and word, who has created and shared invaluable insight with me, and now shares it with those who have the good fortune to discover it here.

Regan Huff, poet and senior acquisitions editor for the University of Washington Press, beyond clever and wise and caring, who has graciously guided this complex story into our hands.

Family and good friends who have believed in this project throughout the years, even though I have never been very good at explaining, why the Duwamish River?

Those who have helped share earlier parts of this work: the Burke Museum of Natural History and Culture, the Seattle Art Museum Gallery, Carolyn White and Laura Poston at Saint Mark's Episcopal Cathedral, and George Blomberg at the Port of Seattle. I am also grateful to the *Seattle Times*; I first became intrigued by the river during my years as a staff photographer, and I thank the *Times* for publishing periodic installments of my own continuing work and for granting

permission to include in this book two images made during early assignments.

Blue Earth Alliance board, members and supporters, for encouragement and sponsorship.

Christine Cox, Buz and Jean Reese, Lynda Mapes, Robert Kemp, Natalie Fobes, Barry Wong, Carol Nakagawa, Alan Berner, Louise Jones-Brown, Eberhard Riedel, Bart J. Cannon, Gene Gentry McMahon, Robert Adams, Kevin Li, Mike Sato, Neal Chism, James Rasmussen, BJ Cummings, Alberto Rodriguez, Cari Simson, Chris Wilke, Cecile Hansen, Mike Evans, Patrick C. Trotter, Jeff Cordell, Beth Armbrust, Allison Hiltner, Clay Eals, Larry Fechter, Craig Welch, Joe Rankin, Sean Sheldrake, Dhira Brown, Andrew Whiteman, Erin Younger, Barbara Shaiman, and many others, for inspiration without measure.

endured my several visits, and once retrieved my daughter's teddy bear when she dropped it in a holding pond. Discussions of the history of the Duwamish people and Seattle's history more broadly benefited from *Native Seattle: Histories from the Crossing-Over Place*, by Coll Thrush; *Emerald City: An Environmental History of Seattle*, by Matthew Klingle; and *The Price of Taming a River*, by Mike Sato. Thanks to an anonymous reviewer for helpful comments on an early draft. To all these people I owe a great deal, and any errors that remain are my own. Lastly, endless thanks to Eleanor and Bay, of course.

ERIC WAGNER

First, thanks so, so much to Tom Reese. His dedication to the Duwamish River has been an inspiration, and I'm grateful for his willingness to collaborate with someone relatively new to the scene. Thanks to the staff of the University of Washington Press, and especially Regan Huff for her guidance and generosity throughout. The staff at the Duwamish Longhouse and Cultural Center helpfully answered all my questions. Thanks to Jeremy Grisham of the Veterans Conservation Corps for hosting the cleanup at Hamm Creek. George Blomberg and Kym Anderson, both of the Port of Seattle, cheerfully took me out on that cold, cold winter day to show me Terminal 117, and brought feeling back to my extremities with clam chowder afterwards. Art Mains, the environmental manager of the Roosevelt Regional Landfill, kindly spent an afternoon driving me all over the landfill and explaining its ways. And the staff at the Soos Creek Hatchery

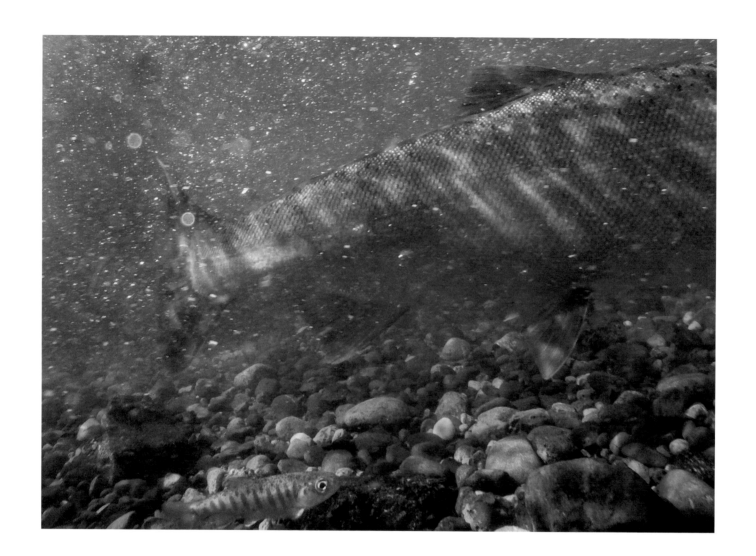

RESOURCES

For information about the Duwamish River, some tribes historically associated with the river, the Superfund designation and process, and cleanup efforts, visit the following:

Duwamish River Cleanup Coalition/
Technical Advisory Group
duwamishcleanup.org

Environmental Protection Agency
yosemite.epa.gov/r10/cleanup.nsf/sites/LDuwamish

Lower Duwamish Waterway Group
ldwg.org

Puget Soundkeeper Alliance
pugetsoundkeeper.org

Port of Seattle
portseattle.org/Environmental/
 Site-Clean-Up/Duwamish

City of Seattle
seattle.gov/util/myservices/drainagesewer/
 pollutioncontrol/lowerduwamishwaterway

King County
kingcounty.gov/services/environment/watersheds/
 green-river/OurDuwamish.aspx

State of Washington, Department of Ecology
ecy.wa.gov/programs/tcp/sites_brochure/
 lower_duwamish/lower_duwamish_hp.html

Boeing Company
boeing.com/principles/environment/duwamish

Duwamish Tribe
duwamishtribe.org

Muckleshoot Tribe
muckleshoot.nsn.us

Suquamish Tribe

suquamish.nsn.us

National Oceanic and Atmospheric Administration

darrp.noaa.gov/hazardous-waste/lower-duwamish-river

Environmental Coalition of South Seattle

ecoss.org

Duwamish Alive!

duwamishalive.org

**People for Puget Sound/
Washington Environmental Council**

wecprotects.org/issues-campaigns/puget-sound

Duwamish Artist Residency

duwamishresidency.com

IMAGE CREDITS

Unless otherwise noted here, all photos are by Tom Reese.

PAGE VI: Map by Robert Kemp. Sources: King County Department of Natural Resources and Parks (DNRP); USHarbors.com; Puget Sound River History Project, University of Washington; Manuscripts, Archives, and Special Collections, Washington State University; USGS; Patrick C. Trotter

PAGE 4: Reproduction of historic map courtesy of Kroll Map Company, Seattle, Washington

PAGE 5: Courtesy of U.S. Environmental Protection Agency

PAGE 20: Courtesy of the Seattle Municipal Archives, item no. 87

PAGES 101 AND 132: Tom Reese/the *Seattle Times*